IMAGES
of America

WHITESTONE

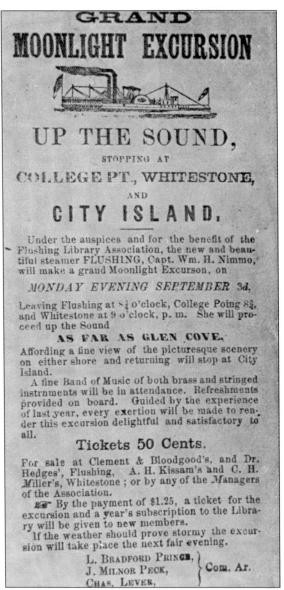

GRAND
MOONLIGHT EXCURSION

UP THE SOUND,

STOPPING AT

COLLEGE PT., WHITESTONE,

AND

CITY ISLAND,

Under the auspices and for the benefit of the
Flushing Library Association, the new and beautiful steamer FLUSHING, Capt. Wm. H. Nimmo,
will make a grand Moonlight Excurson, on

MONDAY EVENING SEPTEMBER 3d,

Leaving Flushing at 8 o'clock, College Poing 8¾,
and Whitestone at 9 o'clock, p. m. She will proceed up the Sound

AS FAR AS GLEN COVE.

Affording a fine view of the picturesque scenery
on either shore and returning will stop at City
Island.

A fine Band of Music of both brass and stringed
instruments will be in attendance. Refreshments
provided on board. Guided by the experience
of last year, every exertion will be made to render this excursion delightful and satisfactory to
all.

Tickets 50 Cents.

For sale at Clement & Bloodgood's, and Dr.
Hedges', Flushing, A. H. Kissam's and C. H.
Miller's, Whitestone ; or by any of the Managers
of the Association.

By the payment of $1.25, a ticket for the
excursion and a year's subscription to the Library will be given to new members.

If the weather should prove stormy the excursion will take place the next fair evening.

L. BRADFORD PRINCE, }
J. MILNOR PECK, } Com. Ar.
CHAS. LEVER, }

This is an advertisement for the Grand Moonlight Excursion of the new steamer *Flushing*, which took place on the night of Monday, September 3, 1910. It departed Whitestone at 9:00 p.m. from the Whitestone Coal and Yacht Supply excursion landing. The trip was done for the benefit of the Flushing Library Association. For only $1.25 passengers received one ticket and a year's subscription to the library. (Queens Historical Society Collection.)

On the cover: The crown jewel of Whitestone's historic homes is the estate of Arthur Hammerstein, who along with his wife, Dorothy Dalton, lived here until his death in 1955. Named *Wildflower* after his successful 1923 Broadway musical, Hammerstein's mansion is located on the water's edge at the end of Powells Cove Boulevard. The sun glistens off two gorgeous statues, which flank the rear entrance. Beyond the beautiful lawn is Flushing Bay. The imperial shingle tiles up on the roof were handmade. After being abandoned for many years, the mansion was turned into a popular catering hall called Ripples on the Water. (Studio of John Adams Davis.)

IMAGES
of America

WHITESTONE

Jason D. Antos

ARCADIA
PUBLISHING

Published by Arcadia Publishing
Charleston, South Carolina

Printed in the United States of America

Library of Congress Catalog Card Number: 2006927078

For all general information contact Arcadia Publishing at:
Telephone 843-853-2070
Fax 843-853-0044
E-mail sales@arcadiapublishing.com
For customer service and orders:
Toll-Free 1-888-313-2665

Visit us on the Internet at www.arcadiapublishing.com

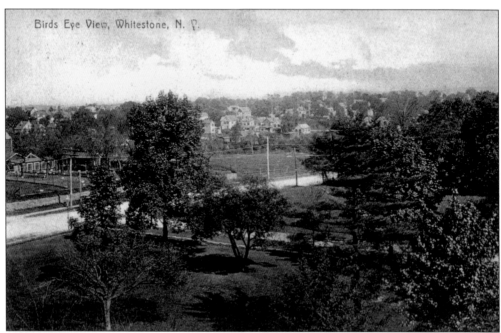

This c. 1900 postcard offers an overview of the center of Whitestone by Fourteenth Avenue and 150th Street. In the background among the thick woodland is the development of new homes as the town begins to transform from a rural farming community into a major New York City suburb. (Courtesy of Queens Borough Public Library, Long Island Division, Postcard Collection.)

CONTENTS

ACKNOWLEDGMENTS

This book could not have been made possible without the love and support of my family and the people of Whitestone.

Research for this project was made possible by several different parties, to whom I am forever grateful. At the Poppenhusen Institute, I would like to thank assistant director Susan K. Brustmann and Faye Graham. Also, John Hyslop and Judith Todman at the Long Island Division of the Queens Borough Public Library, who were indispensable in the making of this book. American Bridge was vital in finding construction pictures of the Throgs Neck and Bronx-Whitestone Bridges. I would also like to acknowledge Alison McKay at the Bayside Historical Society for her time and help. At the Queens Historical Society, thanks to Mitchell Grubler, Jim Driscoll, and Richard Hourahan for their help as well. I would like to extend special thanks to David Keller for his time and assistance during my research of the Long Island Railroad stations.

On a local level, the Whitestone Branch of the Queens Borough Public Library and Gleason Funeral Home were helpful in providing those final elusive photographs. Last but certainly not least, I am grateful to Erin Vosgien for her time, energy, and going to bat for me in order to make this book a reality.

Thanks to my father for his support and to my mother, Wendy, for taking me on my first tour of Whitestone when I was a child one hot summer day.

In conclusion, there is one person I would like to thank most of all. To my late grandmother and best friend Evelyn Kaye, who smiled with absolute joy when I announced to her that I was going to publish my first book. She passed away just weeks before the completion of this book, which is dedicated to her.

INTRODUCTION

Whitestone sits on a peninsula on the northernmost tip of Queens, the largest of the five boroughs of New York City. It is located on Flushing Bay and the Long Island Sound, which are both fed by the East River parallel to the Bronx. Although Whitestone is flanked by two major bridges, the Throgs Neck and the Bronx-Whitestone Bridges, people are usually in a hurry going north toward New England or southwest to Manhattan and have no time or need to stop in what is one of the most historic neighborhoods in New York City.

The territory known as Whitestone Landing was discovered in 1645 when Dutch immigrants landed on the western part of the town after navigating through the Hells Gate River and into Flushing Bay. When these settlers arrived, it was quickly apparent that they were not alone. The Matinecock Indians, a division of the Algonquin Nation, were the local inhabitants of the heavily wooded and hilly territory. Matinecock is Native American for "People of the Hill Country." The day was April 17, 1684, when the Matinecock Indians signed a deed giving the colonists control of all the land consisting of Whitestone. It was in a wooden house not too far from the water's edge that the eight representatives of the Matinecock tribe met with nine colonists to sign the deed, a document that the natives could neither read nor understand even if translated. They were to put their marks on the large scroll of white paper, thus surrendering their homes and lands bestowed upon them by the Great Spirit. The Matinecock Indian who signed the deed was Tachapousha sachem. He was the grand sachem and chief of Long Island. The other natives were Quasawascoe, Tuscaueman, Werah Getharum, Nuham, Thrushewequawm, Nunhams, and Oposon. The white men who received the land are named in the deed as Elias Doughty, Thomas Willet, John Bowne, Mattleys Harvey, Thomas Hicks, Richard Connell, John Hinchman, Johnathan Wright, and Samuel Hoyt. The document stated that in trade for the territory, the Matinecock Indians would receive one ax for every 50 acres!

By 1724, all of the Matinecock inhabitants had left Whitestone and headed west. It is interesting to point out that both natives and colonists during the period of 1645–1724 lived in harmony. Not one incident of murder, theft, or lynching was ever recorded.

With the natives gone, the Dutch and increasing English and Irish settlers made Whitestone into a prosperous farming community. The town also had several deposits of clay. The discovery of clay led to the town's first form of industry. The clay was used to produce pots, spoons, and peace pipes, which became a very popular product. Whitestone was the setting for many historical events of the Revolutionary War. Francis Lewis, the New York representative who signed the Declaration of Independence, had a huge farm by Flushing Bay just several hundred feet from where the Bronx-Whitestone Bridge sits today. His patriotic actions proved costly

when in the fall of 1776, British troops entered Whitestone and destroyed Lewis's home and abducted his wife.

As Whitestone entered the 1800s, the town became more industrial with the arrival of John D. Locke. His factory, which is still located on Clintonville Street, produced tin and copper products as well as hot irons for clothing and tools. With the existence of a factory, the population of Whitestone grew. By 1860, the population had expanded to 650 people, a high increase in comparison to the several homesteads that had existed since the early 18th century.

By the end of the Civil War, Whitestone boomed. The economy of the North grew and New York City benefited greatly from this prosperity. With the arrival of the railroad in 1869, Whitestone saw the opening of saloons and hotels.

On January 1, 1898, Queens County became a borough of New York City. With the opening of the Queensborough Bridge in 1909, people moved by the tens of thousands to the wide open land of Queens.

Whitestone became an idyllic spot for celebrities and upper class citizens. The quiet country setting by the seaside just 10 miles outside of Manhattan was the perfect combination.

With the arrival of the world's fair in 1939, Whitestone received a new addition: the Bronx-Whitestone Bridge. The span measured 2,300 feet, making it the fourth-longest bridge in the world at the time. The bridge, designed by Othmar Ammann, was constructed in just 23 months, 60 days ahead of schedule. On the day of its grand opening on April 29, 1939, just 24 hours before the opening of the world's fair in Flushing Meadows, the Bronx-Whitestone Bridge was considered one of the most beautiful bridges in the world. At the ribbon-cutting ceremony, Robert Moses described the bridge as "architecturally, the finest suspension bridge of them all."

In the years that followed, Whitestone experienced an expanding population. In the late 1950s, the final remaining farmland in Whitestone, located at Cryder's Point by the water's edge consisting of the northernmost tip of Queens, was purchased by William Levitt of Levitt and Sons Real Estate Developers. Levitt was responsible for Levitttown in Nassau County, Long Island. A massive multi-apartment building complex was created over an area of 40 acres. In 1961, Ammann and Moses teamed up once again to build the Throgs Neck Bridge. It would be the last suspension bridge ever built in New York State. This time it would be the return of the world's fair to Queens in 1964 for which the Throgs Neck Bridge was built, to help relieve traffic from the Bronx-Whitestone Bridge and Whitestone Expressway.

Whitestone's cultural landscape has changed since the time of the Dutch. The town consists of Irish, Greeks, Koreans, and Italians. Many families have lived there for generations, since before the time of the 1939 New York World's Fair.

Today Whitestone is a town caught in a battle between preserving its past and the creation of a new modern suburb. The latter is currently winning. Historic places, due to fact that they are not listed as a historical or national landmark, have met their fate with the bulldozers of real estate companies that are tearing up these structures at an alarming rate. New structures are rapidly dotting the landscape; on average, three homes a month have a date with the wrecking ball, causing the Whitestone of the past to slowly slip into the darkness of obscurity.

That is the reason for this book. Its publication is not only to serve as a time capsule for those who remember, but for the future generations of Whitestone and New York City who otherwise would never have known about the glorious days gone by.

Whitestone Yacht Club
Foot 25th Street

Whitestone, L. I. _Feby 28_ 190 8

Dear Sir:

There will be a _Regular_ meeting of the Whitestone Yacht Club at the club house on _Tues_ evening _March 3_ at 8.00 P. M.

As business of importance will be brought before the meeting, your presence is earnestly requested.

Yours very truly,

Geo Naffe Jr

Secretary.

This invitation to the Whitestone Yacht Club, sent to Jon D. Mahen of Brookyln, is dated February 28, 1908. The card is announcing that there will be a regular meeting at the club house on March 3 at 8:00 p.m.

One

IN THE BEGINNING

It must have appeared like paradise to the sea-weary Dutch settlers in 1645, with its beautiful forests scattered across wide rolling planes. The Matinecock Indians and newly arrived settlers lived in harmony as Whitestone became a prosperous farming community. The town was established and called Cookie Hill, but then quickly reverted back to the original name, which was derived from the large glistening white limestone boulder that the settlers first encountered on that very first day—Whitestone.

Green Hills at Bayside, L. I.

This depiction of Whitestone and its neighboring community of Bayside shows exactly how the Dutch discovered the territory in 1645. Trees and an abundance of vegetation among rolling hills framed an idyllic location for the settlers. The local inhabitants were the Matinecock Indians, a division of the Algonquin Nation. Matinecock means "People of the Hill Country." (Author's collection.)

This beautiful site of an oak and beech tree–lined path marks the perfect beginning for one's journey through the history of Whitestone. (Author's collection.)

Newly arriving Dutch settlers bring their families and valuables ashore after landing in 1645 at the present-day site of Francis Lewis Park by the base of the Bronx-Whitestone Bridge. This postcard depicts a traditional Dutch landing party. (Author's collection.)

This is the resting place of the final Matinecock Indian. The last of the Matinecock Indian tribes vanished from the area around 1724. (Photograph by Jason D. Antos.)

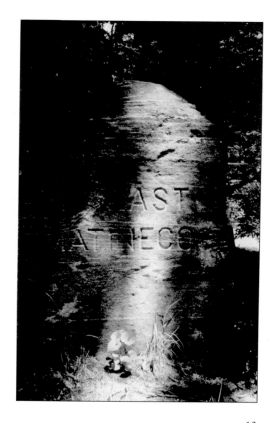

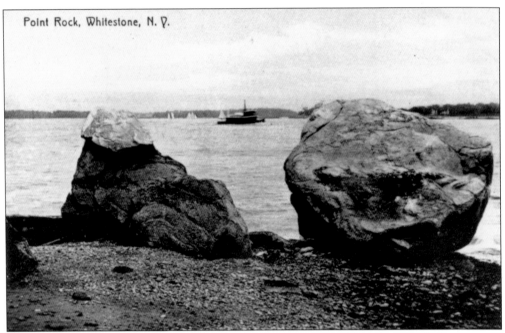

Point Rock, Whitestone, N. Y.

Pictured here are the two large white boulders from which the Dutch named this territory Whitestone. These rocks were created when a huge glacier collided with the eastern seaboard. The glacier became what is known today as Long Island, which includes Queens County. (Courtesy of Queens Borough Public Library, Long Island Division, Joan Kindler Postcards.)

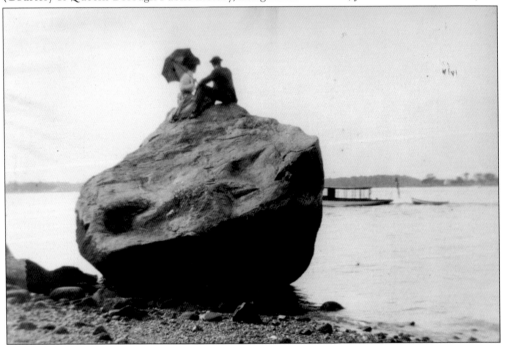

This famous photograph, from the collection of the Queens Historical Society, shows a Victorian couple sitting atop the famous white boulder that gave Whitestone its name. (Courtesy of Queens Historical Society Collection.)

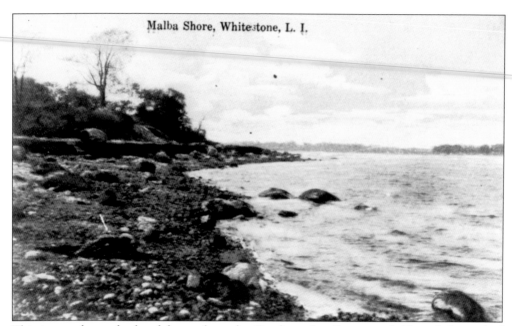

Malba Shore, Whitestone, L. I.

This image shows the beachfront where the Dutch settlers first arrived. Toward the end of the shoreline, near the trees, is where the entrance ramp to the Bronx-Whitestone Bridge is now located. (Courtesy of Queens Borough Public Library, Long Island Division, Joan Kindler Postcards.)

Cryders Lane Whitestone L.

This postcard from 1912 shows how Whitestone appeared to the settlers and its local inhabitants, the Matinecock Indians, in the 17th century. (Courtesy of Queens Borough Public Library, Long Island Division, Postcard Collection.)

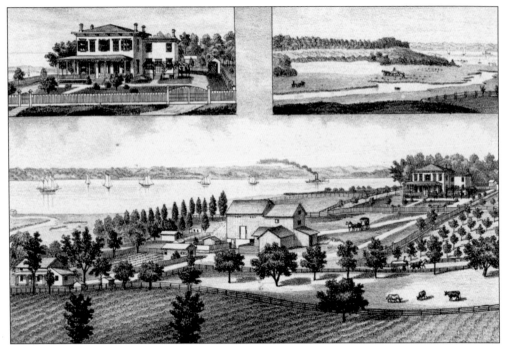

This beautiful etching shows the Schenck homestead located on the outskirts of Whitestone. This is a very accurate depiction of farm life in Whitestone and Queens County prior to the Civil War. The seaside location was ideal for trading and receiving goods for farming. (Author's collection.)

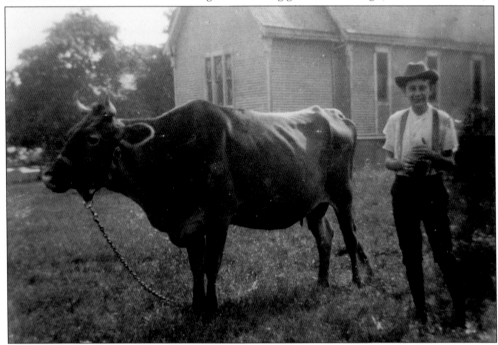

Farmer Tim Connelly poses proudly with his cow behind the First Presbyterian Church on Twelfth Avenue. This is one of the only surviving photographs of Whitestone's farming days. (Courtesy of Queens Historical Society Collection.)

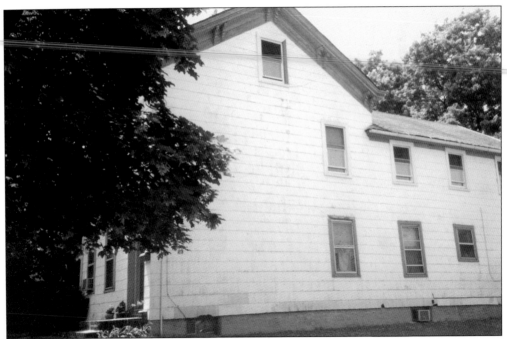

The Connelly farmhouse, built around 1880, is one of the oldest farmhouses in Whitestone. It still stands at the corner of Twelfth Avenue and 150th Street, adjacent to the First Presbyterian Church, which bordered their farmland. (Photograph by Jason D. Antos.)

Pictured here is the factory started by John D. Locke in 1854. The pioneer tinware manufacturer built this stamping mill on what is now Clintonville Street. Most of his workers moved here with their families from Brooklyn. The following year, in 1855, the town experienced its first major economic boom. (Photograph by Jason D. Antos.)

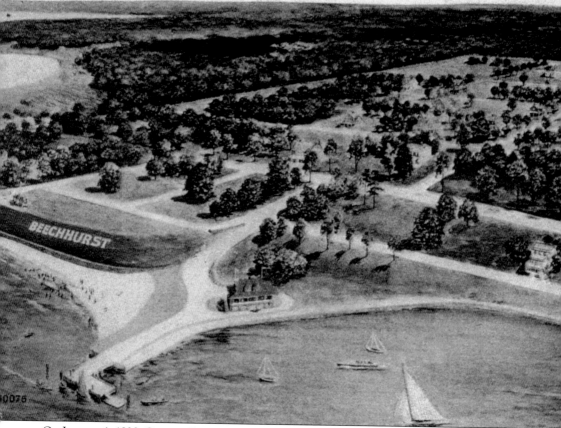

Bird's-eye View of Beechhurst, L.I.

BEECHHURST

On January 1, 1898, Queens County was incorporated into the City of New York as part of the five boroughs. Whitestone was affected by this change. In 1906, the suburb of Beechhurst was developed by the Powell Development Corporation and the Shore Acres Realty Company to accommodate the increase of the town's population. At the bottom of this illustration is the Beechhurst Yacht Club, which was located at the end of 154th Street. (Courtesy of Virginia Kreymer.)

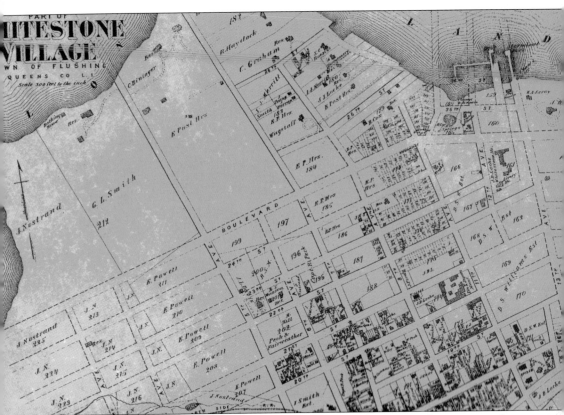

This map from 1890 shows the growing population of Whitestone, which at this time was close to 1,000 people. (Author's collection.)

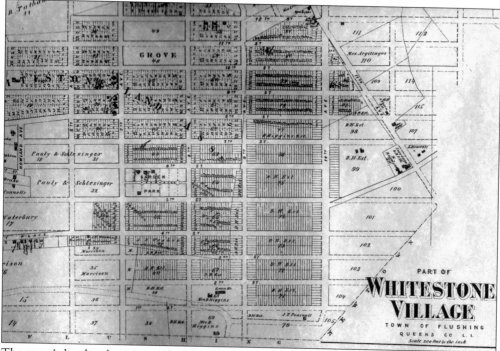

The town's borders begin to move southward as more farms and homesteads appear. Among them are properties belonging to factory owner John D. Locke. (Author's collection.)

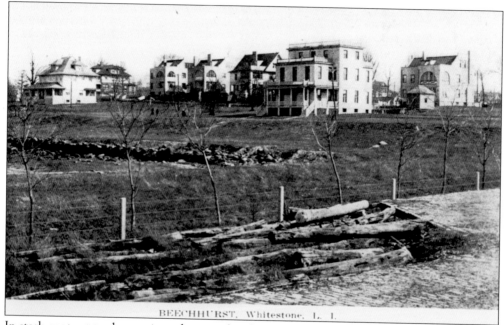

BEECHHURST, Whitestone, L. I.

In stark contrast to the previous photographs, this postcard shows that the woodland has been cleared away and the urbanization of Whitestone has begun. Notice how the homes are built atop the rolling hills for which the Matinecock people were named. (Courtesy of Queens Borough Public Library, Long Island Division, Joan Kindler Postcards.)

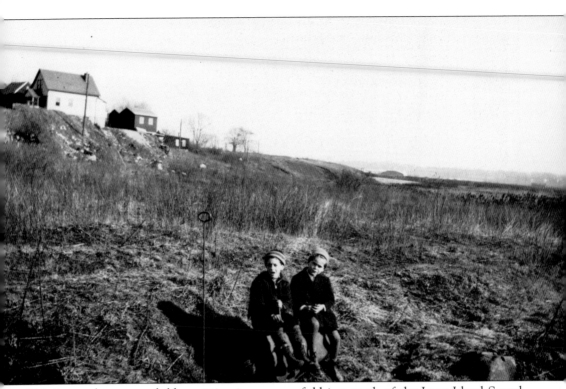

This image shows two children sitting in an open field just south of the Long Island Sound around 1900. The homes in the background are being built as Whitestone becomes a suburb of New York City. The Bronx-Whitestone Bridge would appear almost 40 years later, just several hundred feet from this spot. (Courtesy of Queens Public Borough Public Library, Long Island Division, Ralph Solecki Photographs.)

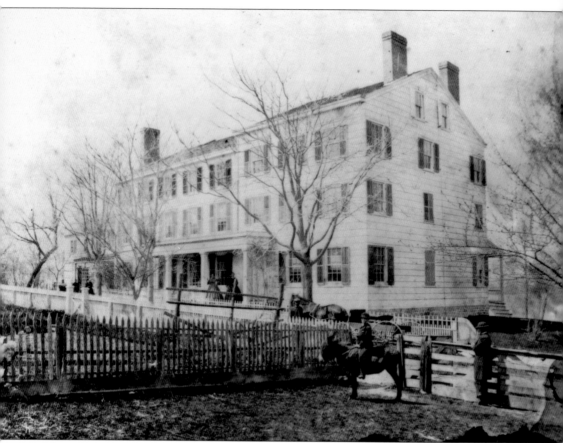

This 1854 photograph shows the homestead of New York City governor DeWitt Clinton. Two women stand on the front porch and an African American man, probably a stable boy, stands with a horse behind the white picket fence. (Courtesy of Queens Borough Public Library, Long Island Division.)

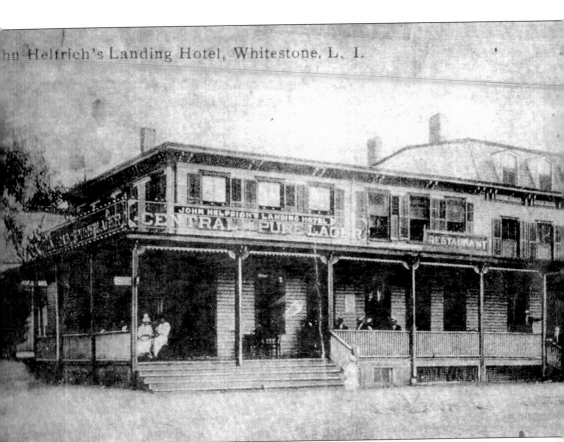

Located at 152nd Street and Sixth Road is John Helfrich's Landing Hotel, pictured here in 1907, a very popular spot in the pre-Prohibition era. The existence of the hotel resulted from the growth of Whitestone's population, which was heavily stimulated by the opening of the Locke factory. (Courtesy of Virginia Kreymer.)

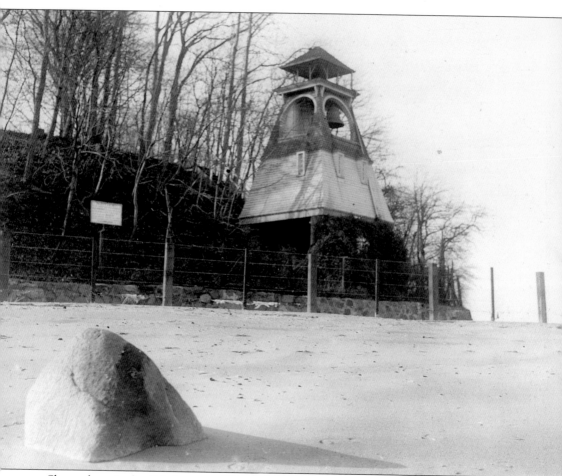

Shown here is the lighthouse at Whitestone Point, which was located at the foot of Second Avenue and 149th Street, as pictured here in 1912. It was in operation from 1889 until 1913 before being torn down and replaced with a less ornate looking structure. (Courtesy of United States Coast Guard.)

Two

A Town is Born

After the initial boom when John D. Locke opened up his tinware factory and mill, Whitestone experienced a second, more powerful rush after the opening of the Queensborough Bridge in 1909. This bridge served as the gateway from New York City into the quiet serene atmosphere of Long Island. Whitestone became a country-style retreat. It was far from the bustling crowds of Manhattan Island but not far enough to inconvenience city folks from getting back home or to work. When DeWitt Clinton of Maspeth, Queens, was governor of New York State, he settled in Whitestone. The area called itself Clintonville in his honor, but reverted once again to the good old name of Whitestone after a post office was established in 1854.

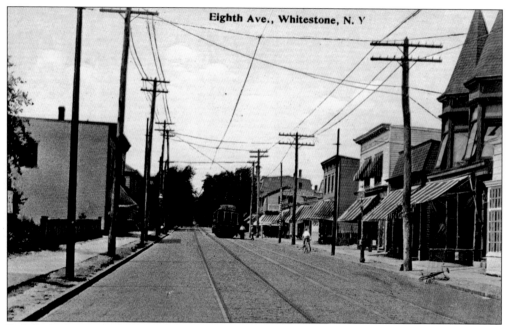

Eighth Ave., Whitestone, N. Y

Eighth Avenue is shown in this postcard from 1910. Peter Zipf's grocery store with the two spires on the roof is to the right. A trolley in the distance travels up the avenue. Today this is 149th Street. The Zipf store sold produce, imported wines, and beer and was also a prosperous hotel. The building still exists. (Courtesy of Queens Borough Public Library, Long Island Division, Postcard Collection.)

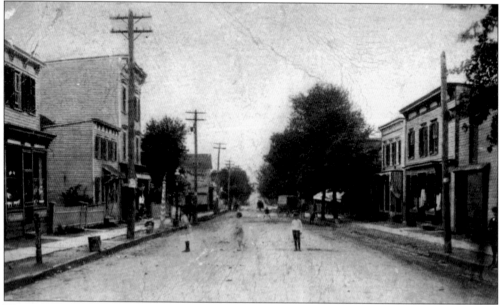

This is a typical street scene in the early days of Whitestone. A horse-drawn carriage can be seen in the background as children play in the middle of the street. In the background on the left is the old Whitestone Lumber. Today this is 150th Street, the town's main shopping district (Courtesy of Queens Borough Public Library, Long Island Division, Postcard Collection.)

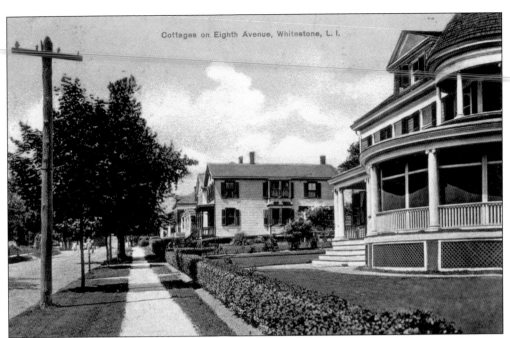

Located on what is now 150th Street are beautiful Colonial cottages and farmhouses. The first house on the right is the Gleason Funeral Home. (Courtesy of Queens Borough Public Library, Long Island Division, Postcard Collection.)

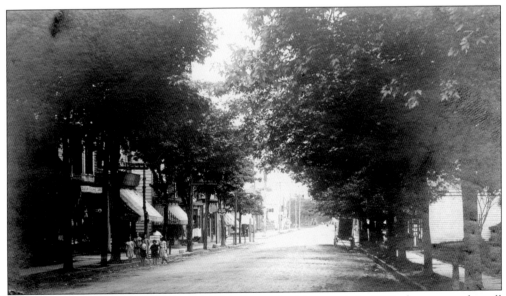

This beautiful glass-plate exposure of 150th Street, looking south in 1908, shows several small children standing in front of the general store. A horse-drawn carriage is parked at the curb on the right-hand side. Just behind the children, a few stores down, is the local telegraph office. (Courtesy of H. Hess.)

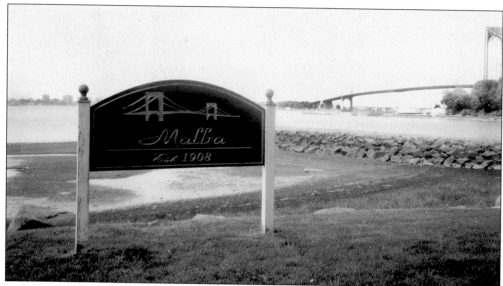

Malba, a suburb of Whitestone, is an acronym for the first letters of the last names of the five developers who started this small private community in 1908. George A. Maycock, Samuel R. Avis, George W. Lewis, Nobel P. Bishop, and David R. Alling were affiliated with the Realty Trust Corporation owned by William Ziegler, "the Baking Powder King." Ziegler had purchased the land in 1900, which amounted to over 200 acres. This photograph shows the welcome sign with the Bronx-Whitestone Bridge in the background. The bridge, however, was not built until 1939. (Photograph by Jason D. Antos.)

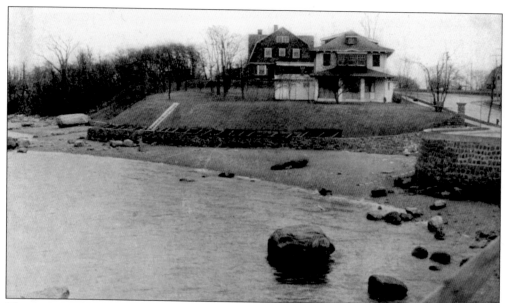

These two exclusive homes are located at the foot of Malba Drive, overlooking the Flushing Bay. This photograph was taken from the dock that hosted the ferryboats that ran between Whitestone and Westchester County. (Courtesy of Queens Borough Public Library, Long Island Division, Postcard Collection.)

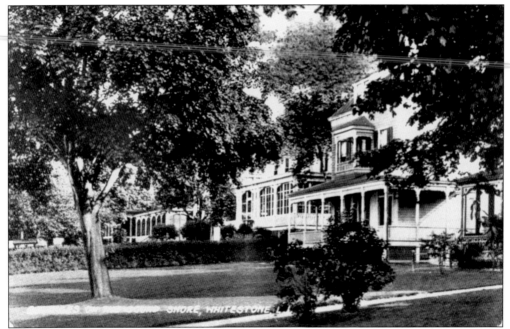

Shore Road, which is now known as Powells Cove Boulevard, features exclusive seaside estates. This postcard from 1906 shows the rapid development of this once rural farm community, which is quickly becoming upper class. (Courtesy of Queens Borough Public Library, Long Island Division.)

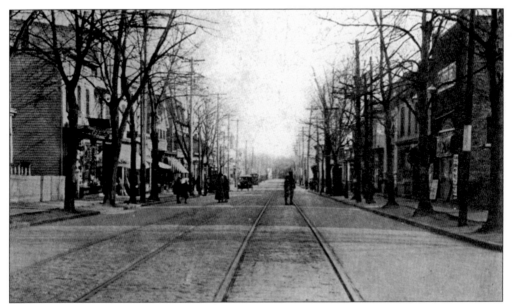

Whitestone village is the main shopping and market section. Private business, post offices, banks, and bakeries line the streets. The first automobiles are seen in the background, driving up the cobblestoned and trolley track–lined avenue. Gerson's Unique Theater is to the right. Today this is 150th Street. (Courtesy of Queens Borough Public Library, Long Island Division.)

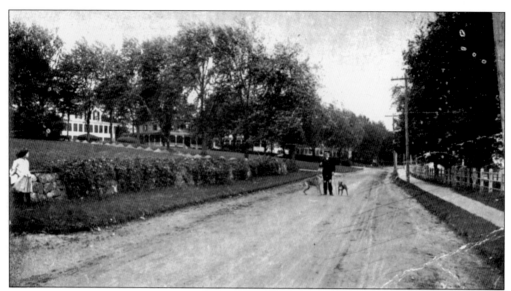

A young girl watches a distinguished gentleman walk his two dogs up Shore Road. To the right is the seawall overlooking Flushing Bay, and on the left are the beautiful Colonial estates. This picture is one of the only surviving pieces of evidence to the glamorous historical homes that once lined this street. (Courtesy of Queens Borough Public Library, Long Island Division, Postcard Collection.)

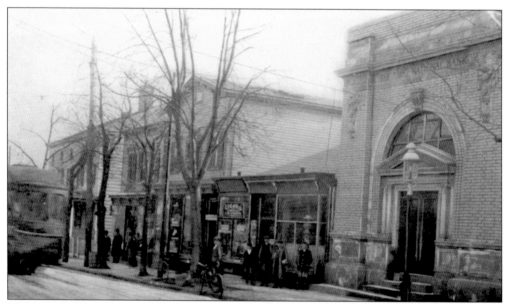

This wonderful picture from 1915 shows a trolley rolling down 150th Street. A group of men with bicycles stand in front the First National Bank located on the right. The presence of a bank was a major symbol of the town's growing population and changing social class. It was built in 1907. (Courtesy of Queens Borough Public Library, Long Island Division, Postcard Collection.)

This image shows the First National Bank during World War I, as Whitestone is growing larger. The title of the bank implies that the town is now servicing people from outside the neighborhood as well. (Courtesy of Queens Borough Public Library, Long Island Division, Postcard Collection.)

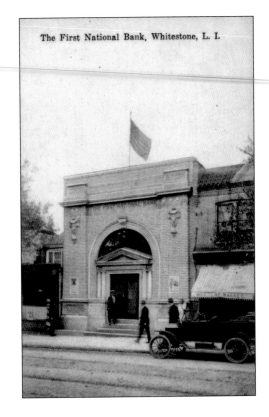

The First National Bank, Whitestone, L. I.

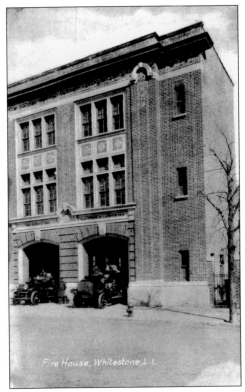

Fire House, Whitestone, L.I.

Pictured here is a symbol of pride for the entire Whitestone community, the firehouse of the 144 Hook and Ladder Company. Fire engines emerge from the garage driven by New York's finest in this promotional photograph from 1915. (Courtesy of Queens Borough Public Library, Long Island Division, Postcard Collection.)

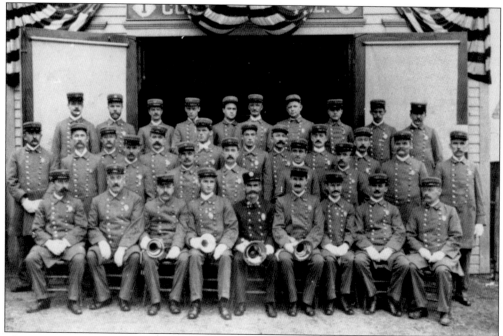

This group photograph from 1915 shows the brave men of the Columbia Hose Company. This local fire department was later one of the first modern-day firefighting companies in the borough of Queens. (Courtesy of Queens Borough Public Library, Long Island Division, Joan Kindler Postcards.)

A 1906 group portrait of Engine Company No. 1 of the Columbia Hose Company is depicted here. The number of the department is proudly displayed on their uniforms. Notice the lanterns in the front row. (Courtesy of Gleason Funeral Home.)

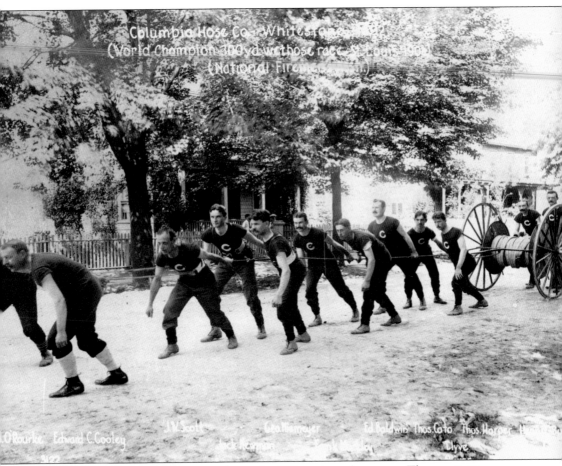

As this photograph from 1892 states, this is the 300-yard wet hose race. These activities were sponsored by the Columbia Club. The firefighters of the Columbia Hose Company wear shirts that adorn a giant C for Columbia. The names of these men are listed below. From left to right are J. O'Rourke, Edward C. Cooley, J. W. Scott, Jack Newman, Geo Niemeyer, Frank Markloy, Ed Baldwin, Thomas Cato, Cyive Oliver, Thomas Harper, Henry C. Buncke, and Loius Kiefer. (Courtesy of Queens Borough Public Library, Long Island Division, Borough President of Queens Collection.)

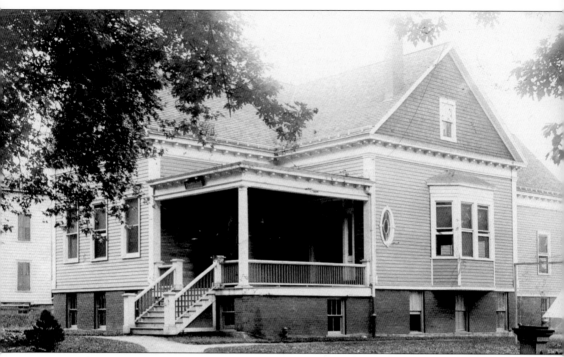

Postmarked on September 30, 1905, this beautiful postcard by H. Hess of Whitestone shows the Columbia Club. This Victorian-style home was located on what is now the Cross Island service road at the corner of 157th Street. It was used by the men and families of the Columbia Hose Company for social gatherings and entertainment. The building to the left still stands today. (Courtesy of H. Hess.)

A bartender and patron pose for this photograph taken inside the Columbia Club. (Courtesy of Queens Borough Public Library, Long Island Division, Weber Collection.)

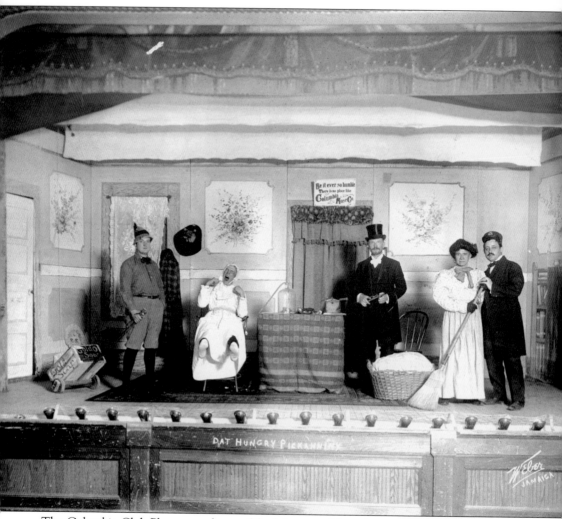

The Columbia Club Players, made up of firefighters and friends, put on a minstrel show called "Dat Hungry Pickanniny." Notice that all the characters are men, even the "woman" on the right. A sign to the rear and above the stage reads, "Be It Ever So Humble, There's No Place Like Columbia Hose Co." (Courtesy of Queens Borough Public Library, Long Island Division, Weber Collection.)

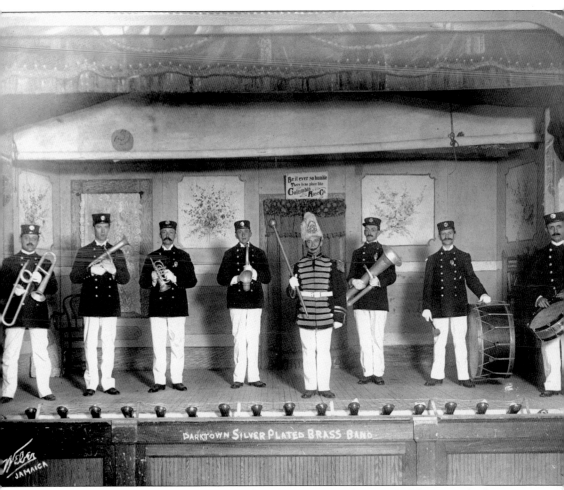

Here the Darktown Silver Plated Brass Band performs on April 11, 1912. These are the brave men of the Columbia Hose Company. (Courtesy of Queens Borough Public Library, Long Island Division, Weber Collection.)

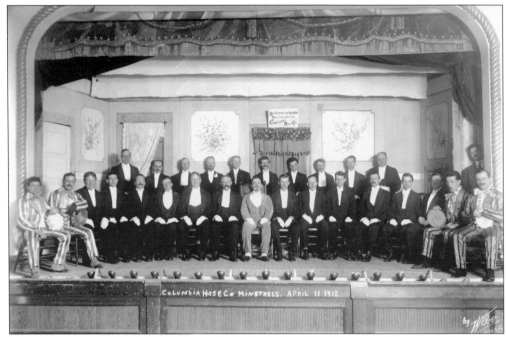

This image depicts a grand production of the Columbia Club Minstrels that was performed on the night of April 11, 1912. This photograph was taken 48 hours before the sinking of the *Titanic*. (Courtesy of Queens Borough Public Library, Long Island Division, Weber Collection.)

Pictured here are the new Victorian-style houses and cottages appearing in the new subdivision of Whitestone called Beechhurst. (Courtesy of Queens Borough Public Library, Long Island Division.)

Shore View, Whitestone, L. I.

A beautiful day for sailing is depicted in this postcard from 1910. Among the private yachts is the ferryboat that transported people from Westchester to Whitestone. The ferry ports were a major source of income for the neighborhood during the early part of the 20th century and established Whitestone as a major trading post. (Courtesy of Queens Borough Public Library, Long Island Division, Joan Kindler Postcards.)

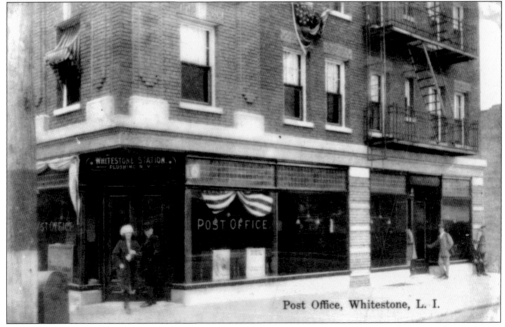

Post Office, Whitestone, L. I.

This is the Whitestone station of the United States Postal Service located on 150th Street. It was this very post office that caused the town's name to revert back to Whitestone after being known as Clintonville. (Courtesy of Queens Borough Public Library, Long Island Division, Postcard Collection.)

Out of all the pictures of historic Whitestone, this one is the most beautiful. A horse-drawn buggy travels along Shore Road around 1900. This picture postcard, taken right before the arrival of the automobile, serves as a reminder of the golden era of Whitestone's past. (Courtesy of Queens Borough Public Library, Long Island Division, Joan Kindler Postcards.)

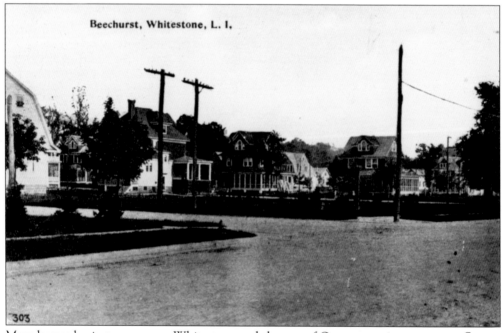

More homes begin to pop up as Whitestone and the rest of Queens continues to grow. Streets become paved, and telegraph and telephone poles line the sidewalks. (Courtesy of Queens Borough Public Library, Long Island Division, Joan Kindler Postcards.)

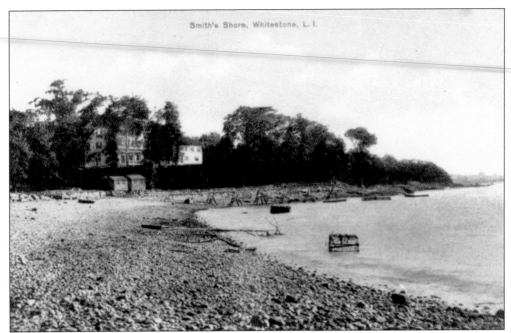

Smith's Shore, Whitestone, L. I.

Here is a view of the 10-acre estate of H. DeWitt Smith by Flushing Bay. The Smith family came from England and lived in the area until the 1920s. In 1937, the homestead just west of 147th Street was demolished to make way for the Bronx-Whitestone Bridge and Francis Lewis Park. (Courtesy of Queens Borough Public Library, Long Island Division, Joan Kindler Postcards.)

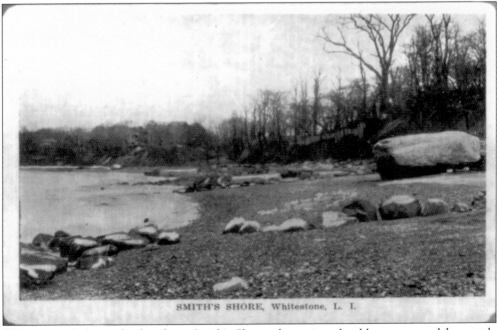

SMITH'S SHORE, Whitestone, L. I.

This postcard shows the beach at Smith's Shore; these giant boulders were used by people bathing in Flushing Bay. Today this marks the beginning of Malba. Farther down the shoreline is where Francis Lewis Park will be built. (Author's collection.)

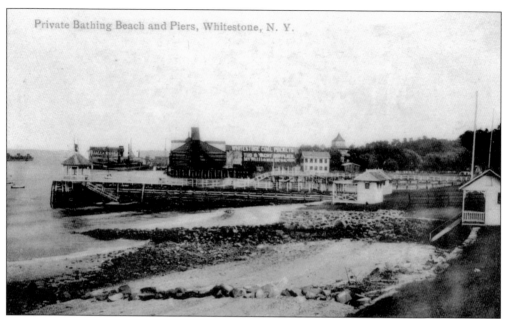

Located at the foot of Clintonville Street was the McWilliams Brothers Whitestone Coal Pockets Tug and Yacht Supply Pavillion for tugboats and private yachts. Excursion parties often landed and departed from this location in the 1880s and 1890s. This waterside supply store was built by the McWilliams Brothers. This photograph is dated July 1917. (Courtesy of Queens Borough Public Library, Long Island Division, Postcard Collection.)

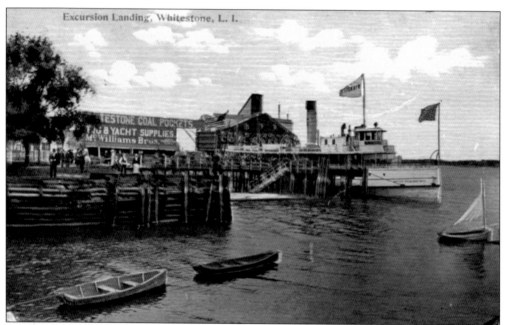

This postcard from 1917 depicts a typical excursion party. A large steamer leaves the docks at the McWilliams Brothers Whitestone Coal Pockets Tug and Yacht Supply Pavillion as a huge crowd looks on. (Courtesy of Queens Borough Public Library, Long Island Division, Postcard Collection.)

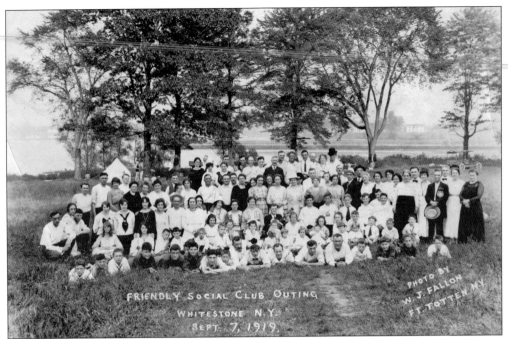

A group of people from a local social club poses for a portrait by the Long Island Sound, on a lovely day at the park. On the other side of the water, in the background, is Fort Totten, which is located in the neighboring town of Bayside. (Gleason Funeral Home.)

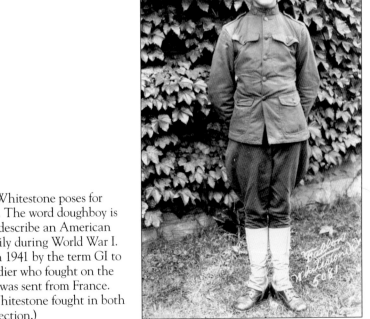

A young doughboy from Whitestone poses for this 1918 picture postcard. The word doughboy is an outdated term used to describe an American infantryman, used primarily during World War I. Doughboy was replaced in 1941 by the term GI to describe an American soldier who fought on the front lines. This postcard was sent from France. Many young men from Whitestone fought in both world wars. (Author's collection.)

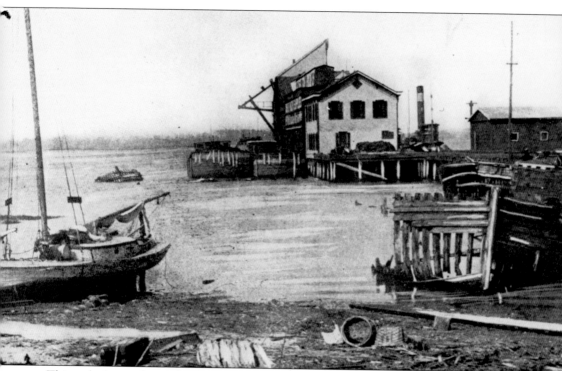

This sad picture shows the final days of the McWilliams Brothers Whitestone Coal Pockets Tug and Yacht Supply Pavillion. Boats by the seashore are broken and rotten, and the beach is littered with debris. This photograph offers a good view of the beautiful two-level home located in the rear of the pavilion, in which the McWilliams brothers lived with their families. (Courtesy of Queens Borough Public Library, Long Island Division, Postcard Collection.)

Three

THE RAILROAD

Perhaps one of the most interesting and forgotten chapters in the history of Whitestone happened between 1869 and 1932, when the Long Island Railroad (LIRR) extended its service out to the far reaches of Queens. In October 1869, the first train station of the Whitestone branch of the LIRR was opened on what is now the service road of the Cross Island Expressway. As Whitestone grew, so did the service. On August 9, 1886, a second station was built down by the water's edge in part of the neighborhood known as Whitestone Landing. This station brought service all the way to the seaside yacht clubs, which in reality were situated in the northernmost section of Queens. And finally, in 1909, a third station was built in Malba for the exclusive private community. All stations were closed down by the city on February 15, 1932.

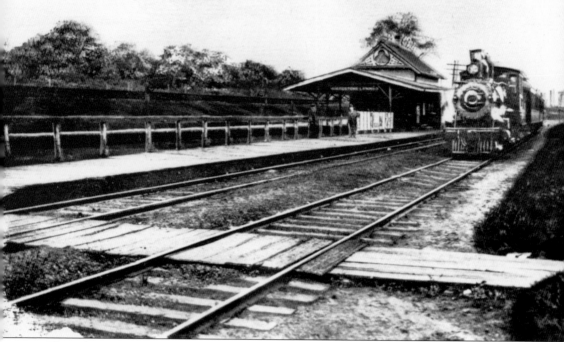

L. I. R. R. Depot,
at Whitestone Landing, L. I.

The Whitestone Landing branch of the LIRR was located between Seventh and Ninth Avenues, just west of 154th Street. Built on August 9, 1886, at the water's edge, the train would originate from this point before journeying to the nearby community of College Point. This photograph from 1908 shows the steam engine pulling into the station while the conductor waits. (Courtesy of Queens Borough Public Library, Long Island Division, Joan Kindler Postcards.)

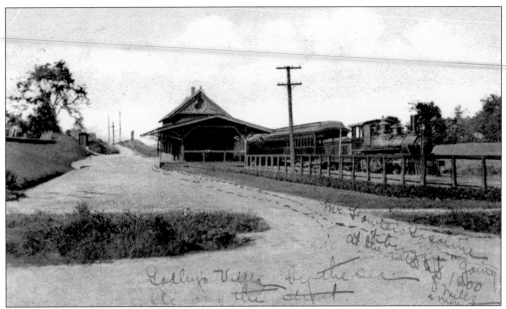

This famous postcard dated May 6, 1910, shows the steam engine pulling out of the Whitestone Landing station headed toward its next stop. (Author's collection.)

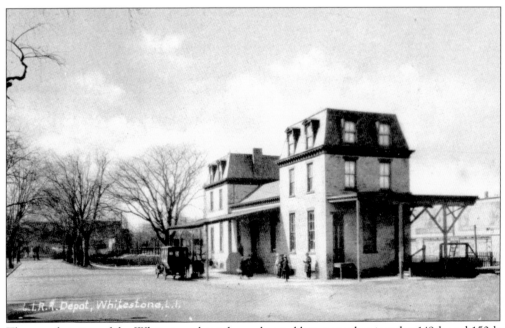

The grand station of the Whitestone branch was located between what is today 149th and 150th Streets. Passengers and horses are shown arriving in front of the station to await the arrival of the train. (Courtesy of Queens Borough Public Library, Long Island Division, Postcard Collection.)

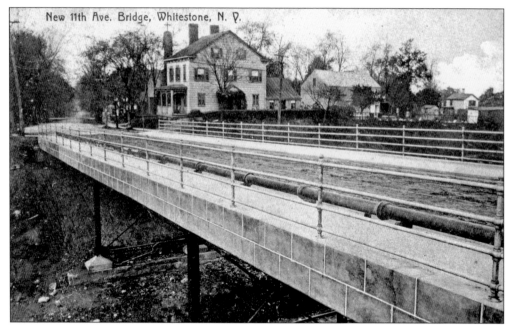

New 11th Ave. Bridge, Whitestone, N. Y.

In this 1915 photograph, train tracks pass beneath a concrete overpass. Today this overpass covers the Cross Island Expressway, of which a portion follows the old train path. (Courtesy of Queens Borough Public Library, Long Island Division, Postcard Collection.)

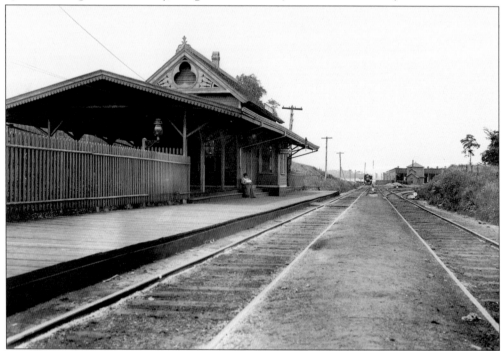

The Whitestone Landing station, shown here in 1911, features a few modern updates. Gas lamps have appeared, and a lone woman sits waiting for the train to start its journey from the water's edge. Above her head is a sign announcing that this station is equipped with telephone and telegram services. (Courtesy of Poppenhusen Institute, the Ron Ziel Collection.)

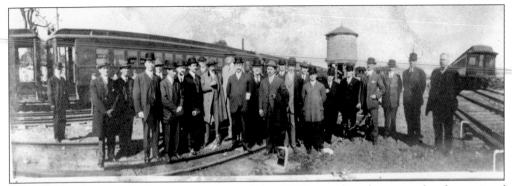

This group photograph shows executives of the LIRR standing between the first pair of electric-powered trains on October 20, 1912. The third rail is visible toward the middle of the group. (Courtesy of Queens Historical Society Collection.)

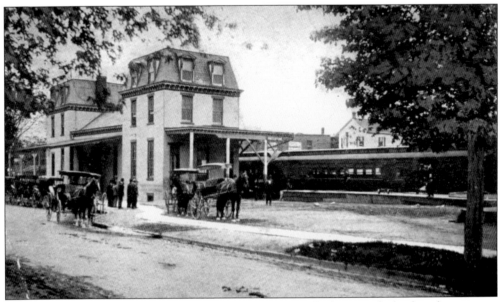

Horse and buggies stand outside on the unpaved road as onlookers watch the first electric train arrive at the Whitestone depot on October 20, 1912. (Author's collection.)

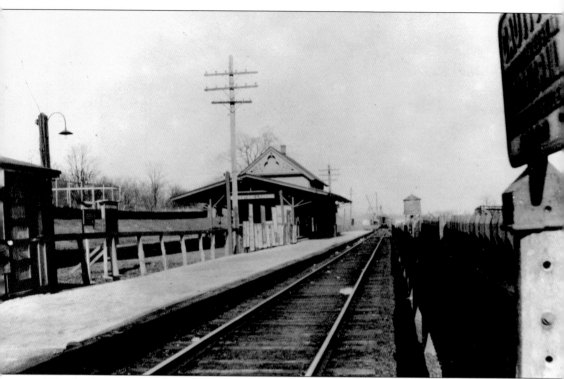

The desolate scene at the Whitestone Landing station in 1925 might be attributed to the advent of the automobile in everyday American life; people no longer take the train. The staff cabin is to the left, and in the background is a more modern-day train receding into the distance. To the right of the photograph is a sign warning people about the third rail. It reads, "Caution Trains Operated By Electric Rail. Trespassing Forbidden!" (Courtesy of the archives of David Keller.)

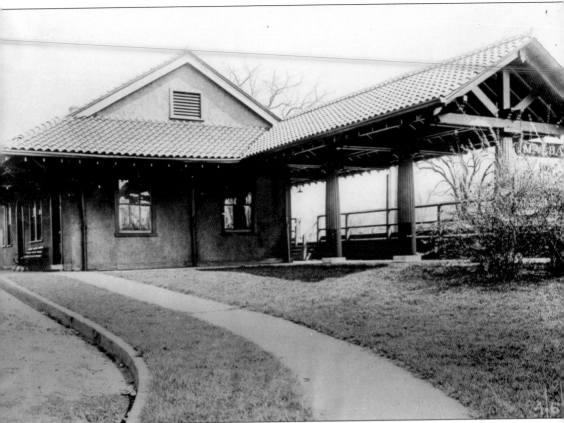

In this photograph dated April 6, 1921, a woman dressed in an elegant hat and fur coat waits for the train at Malba station. Service was extended to this suburb of Whitestone in 1909, the same year the neighborhood was built. The station was shut down on February 15, 1932. (Courtesy of Ron Ziel.)

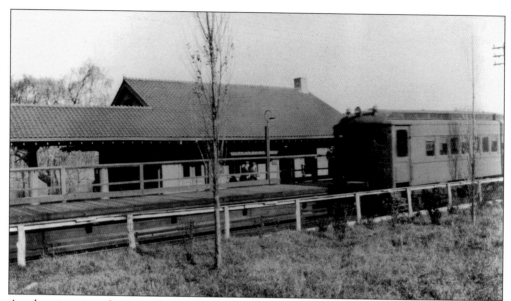

An electric-powered train pulls into the station in this 1925 photograph, showing two gentlemen running to catch it while a woman waits on the platform. (Courtesy of the archives of David Keller.)

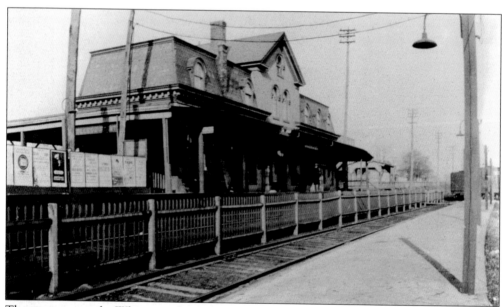

The next stop on the Whitestone line was College Point. The station, located at the eastern end of Eighteenth Avenue, was built in 1869 and opened on August 14 of that year. It was the final stop before the train headed west toward Manhattan. The station was closed on February 15, 1932, and demolished on September 19, 1934. (Courtesy of the archives of David Keller.)

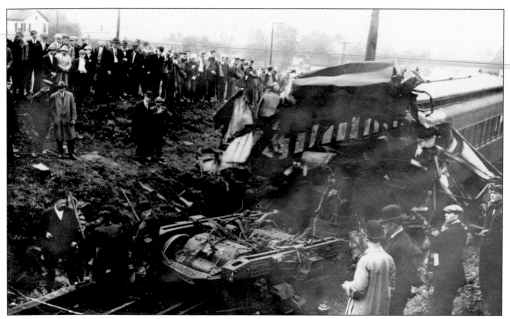

A huge crowd has gathered to view the remains of the derailed LIRR trains, which collided head on. The accident occurred on September 22, 1913, at 6:35 a.m. and resulted from a scheduling error when one train departed 20 minutes late from Whitestone. Three men lost their lives and 45 people were injured. The dead were conductor George Boerckel, and motormen Charles Hoerlin and Frederick Loden. (Author's collection.)

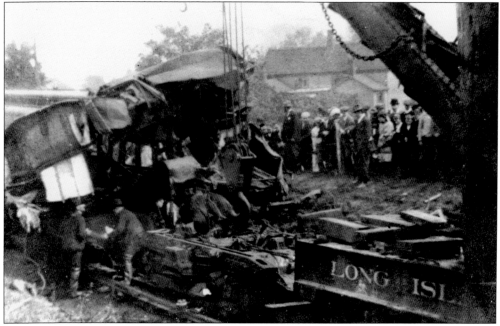

Railroad workers and large cranes begin the gruesome work of removing the debris of another derailed train as a large crowd watches on July 4, 1913. The accident occurred just 100 feet from the underpass on Eighteenth Street, around Fourteenth Avenue and 127th Street. (Author's collection.)

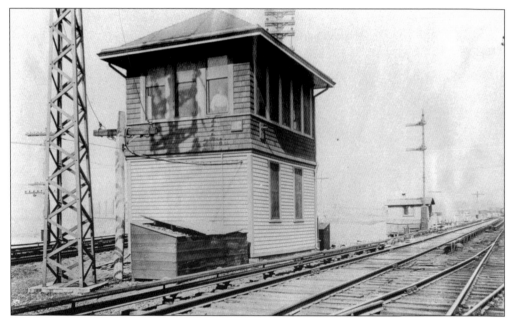

The JC interlocking tower that serviced the junction of the Whitestone and Port Washington branches is shown in this image. The tracks in the background, just behind the tower, serviced the train to Whitestone Landing. A man can be seen in the first window on the right just above the small sign labeled "JC." The tower was in use from June 30, 1914, until February 19, 1932. (Courtesy of the archives of David Keller.)

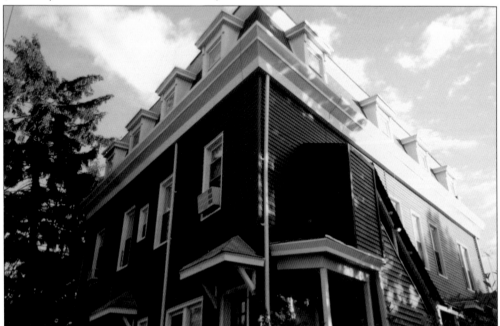

This is the boardinghouse of Harold Fiedelmann, located on the corner of Fourteenth Road and Clintonville Street. This beautiful Victorian-style building housed employees of the LIRR, as well as workers of the Locke factory, which was located 300 yards down the street heading north. (Photograph by Jason D. Antos.)

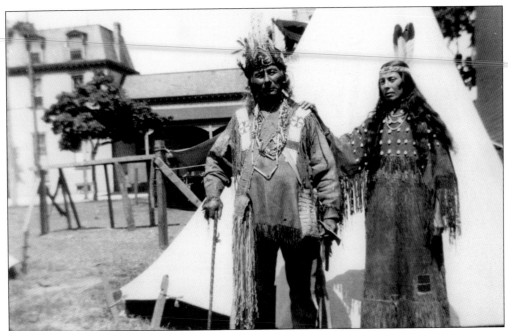

This gorgeous 1912 photograph shows a man and wife of the Kikapoo Indian Tribe posing behind the Whitestone branch of the LIRR on 149th Street. Although they were Native American, these people were more likely gypsies who traveled from town to town putting on medicine shows. Behind them is their teepee. (Courtesy of Queens Historical Society Collection.)

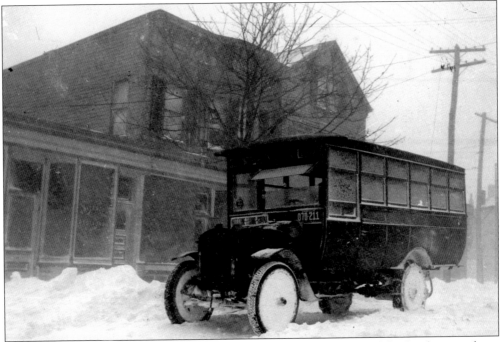

A blizzard struck the metro area on this day in December 1915. One of the first buses makes a scheduled stop on 150th Street while trying to maneuver through the dense and brutal snow. (Courtesy of Queens Historical Society Collection.)

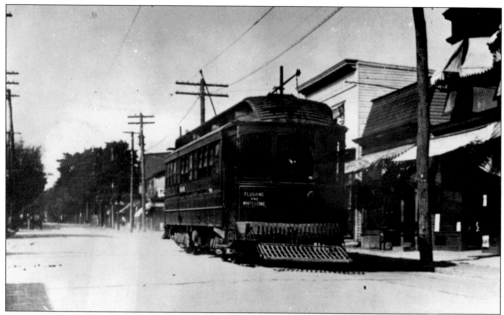

On Friday August 12, 1910, at 11:30 a.m. the first trolley car in Whitestone's history came riding through town, as shown here, in this inaugural photograph. The trolley is traveling north up 149th Street. (Courtesy of Queens Historical Society Collection.)

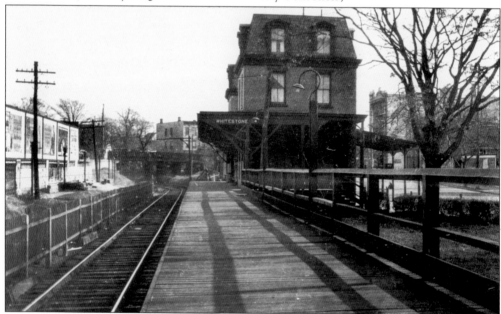

This gorgeous yet sad photograph shows the almost deserted station of the Whitestone branch located on 149th Street, only a few days before it closed. The buildings across the street to the right of the station still remain to this day. The small bridge in the middle of the picture that passes over the tracks is now 150th Street, and the tracks are now the pathway for the Cross Island Expressway. Notice the beautiful billboards alongside the rails on the left. This final image of the Whitestone branch preserves a beautiful and forgotten era. (Courtesy of Poppenhusen Institute, the Ron Ziel Collection.)

Four

A SEASIDE RESORT

Whitestone's population was booming by the arrival of the 20th century, and developers began taking advantage of the town's waterfront location. To lure people into buying property, these developers created beautiful beach and yacht clubs. Although their time was short-lived because of increasing pollution in Flushing Bay and the entire Long Island Sound, swimming and boating became a favorite pastime for many Whitestone residents.

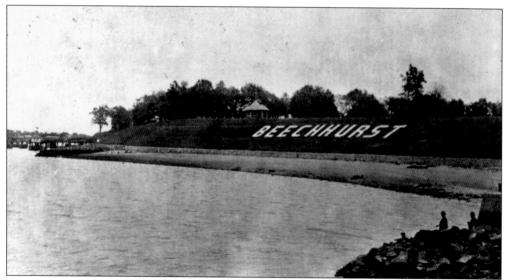

The suburb of Beechhurst was created by wealthy real estate developers in 1906. As the population of Queens grew at a rapid pace, the once heavily wooded area of Whitestone was cleared to make way for several yacht and beach clubs. This sign located on present-day Riverside Drive advertised the new subsection to people yachting on the Long Island Sound. (Courtesy of Queens Borough Public Library, Long Island Division, Joan Kindler Postcards.)

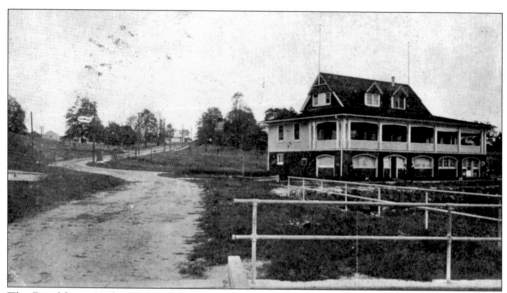

The Beechhurst Yacht Club was located on the present-day site of the Tropicana Orange Juice factory at the foot of 154th Street. (Courtesy of Queens Borough Public Library, Long Island Division, Postcard Collection.)

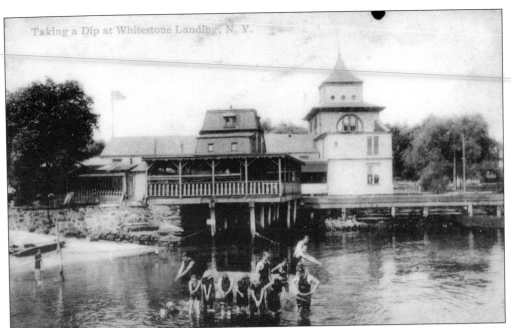

In this image, a group of youngsters takes an afternoon swim in the summer of 1915. The building behind them is Duers Pavilion. Later on, Flushing Bay became so polluted that patrons had to swim in a pool. (Courtesy of Queens Borough Public Library, Long Island Division, Postcard Collection.)

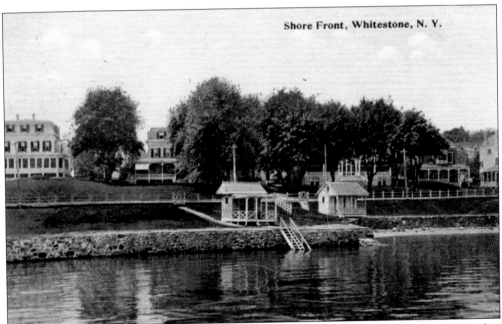

Shore Front, Whitestone, N. Y.

Beautiful and serene, this postcard (dated 1912) shows the small bathing huts that belonged to the occupants of these stunning Colonial mansions located on Shore Road. Steps located at the water's edge helped people in and out of the water. (Author's collection.)

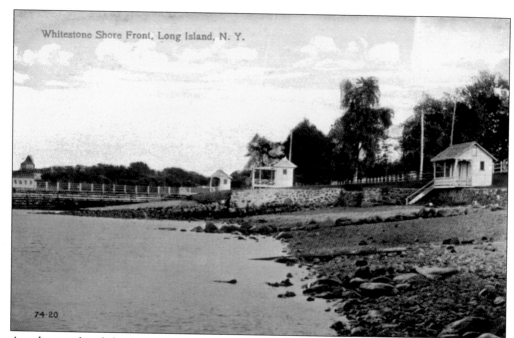

Another angle of the bungalows down by the seaside is depicted here. Today this beach is covered in seaweed and algae, and although it is safe to fish, swimming is not recommended. (Author's collection.)

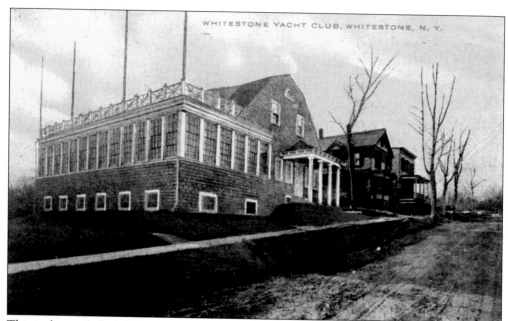

This is the newly built Whitestone Yacht Club located at the water's edge. Notice the unpaved road. (Author's collection.)

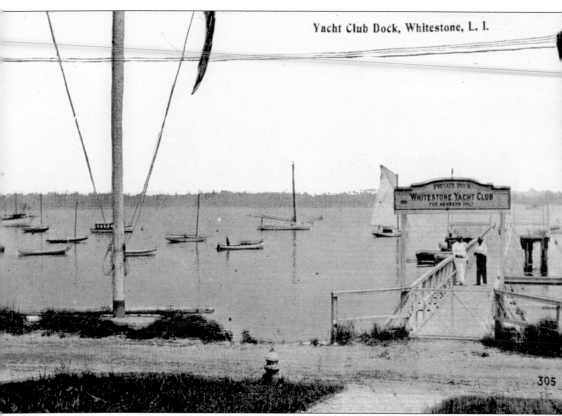

Two men talk on the pier looking out over Flushing Bay. This amazing postcard is dated July 13, 1913. Notice the sign above the docks entrance. It reads, "Private dock. Whitestone Yacht Club. For members only." (Author's collection.)

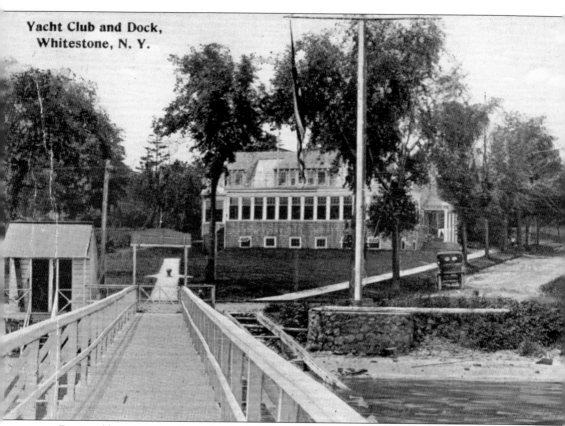

Yacht Club and Dock,
Whitestone, N. Y.

Depicted here is a view from the dock. The road in front of the Whitestone Yacht Club has now been paved. A small bathing hut that housed changing rooms is located to the left. Just to the right of the dock is a platform used in launching small boats into the water. The American flag dangles from the flagpole. That new invention of the day, the automobile (probably belonging to the photographer), sits out in front. (Author's collection.)

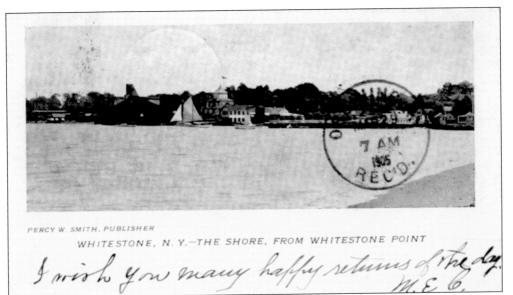

Whitestone Yacht Club
foot 25th Street

Whitestone, L. I. Feb. 1 *190* 8

Dear Sir:

 There will be a Regular *meeting of the Whitestone Yacht Club at the club house on* Tuesday *evening* February 4 *at* 8:00 *P. M.*

 As business of importance will be brought before the meeting, your presence is earnestly requested.

 Yours very truly,

 George Hake
 Secretary.

 per E

An invitation dated February 1, 1908, asks a member to attend a regular meeting on February 4 at 8:00 p.m. On the top portion of the card, it is indicated that the Whitestone Yacht Club was located at the foot of Twenty-fifth Street, which is presently 152nd Street. (Author's collection.)

PERCY W. SMITH, PUBLISHER

WHITESTONE, N. Y.—THE SHORE, FROM WHITESTONE POINT

This very rare picture postcard dated March 29, 1905, shows the main shoreline of Whitestone. Lined up in rows are the main waterfront attractions. From left to right are the McWilliams Brothers' Whitestone Coal Pockets Tug and Yacht Supply, Duers Pavilion, and the Whitestone Yacht Club. The script on the bottom reads, "I wish you many happy returns of the day." (Author's collection.)

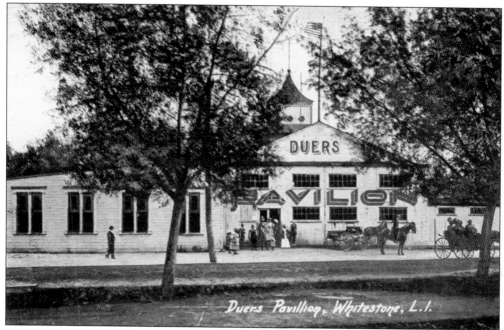

The largest pavilion in Whitestone, Duers Pavilion, was like a seaside amusement park. It featured a beer hall, a nickelodeon, a bowling alley, and a beach and yacht club in the rear, as seen at the top of page 59. With the combination of Prohibition and increasing water pollution, Duers Pavilion was shut down. (Courtesy of Queens Borough Public Library, Long Island Division, Postcard Collection.)

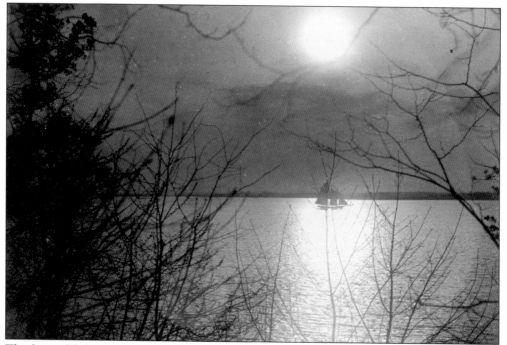

This beautiful photograph from 1898 captures a private yacht moving through the moonlight on the Long Island Sound, by the Whitestone shoreline.

Five

CHURCHES, LIBRARIES, SCHOOLS, AND SPORTS

Whitestone's population features a variety of ethnicities and faiths. Nowhere else is this reflected more than in the abundant amount of churches that will be examined in this chapter. Peoples of Lutheran, Episcopalian, and Greek and Russian Orthodox faiths all practice within a one-block radius of each other. Whitestone is a very self-contained city suburb, featuring two city public schools and many libraries. These institutions of knowledge helped nurture an intelligent community, in a time when education was not available to all people.

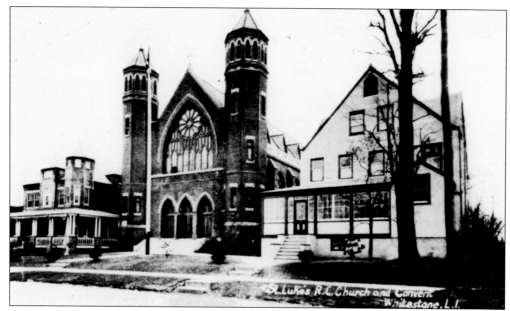

Built in the late 1800s, St. Luke's Roman Catholic Church, pictured in this postcard from 1915, is located on Clintonville Street. St. Luke's is attended mainly by the Italian community of Whitestone, who are the majority culture. To the right of the church is the convent. (Courtesy of Queens Borough Public Library, Long Island Division, Joan Kindler Postcards.)

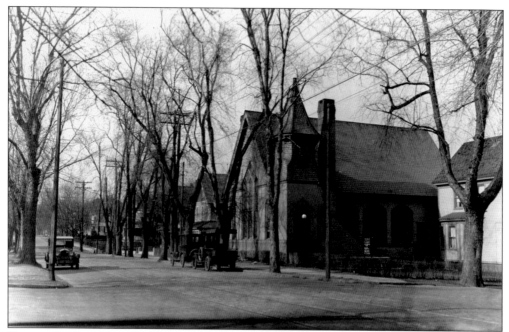

Here is the Lutheran church at the corner of Eighth (presently 150th Street) and Twelfth Avenues. Trolley tracks are visible, and the first cars can already be seen filling up parking space along the curbside. It became the Greek Orthodox Church of Whitestone on Christmas Day 1975. (Courtesy of Queens Borough Public Library, Long Island Division, Eugene Armbruster Photographs.)

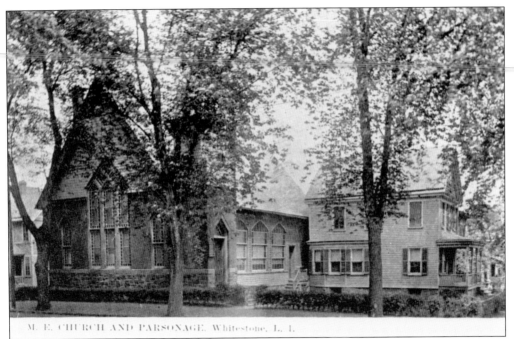

M. E. CHURCH AND PARSONAGE. Whitestone. L. I.

The Methodist Episcopal church and parsonage is depicted in this image from 1912. The parsonage is located to the right of the church. (Courtesy of Queens Borough Public Library, Long Island Division, Joan Kindler Postcards.)

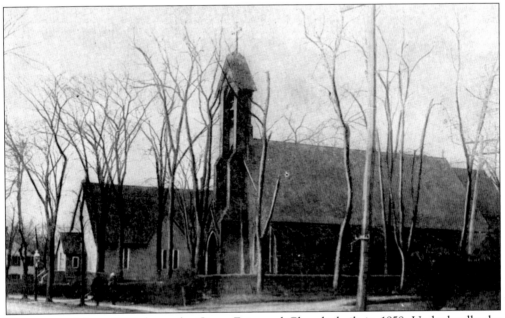

This postcard from 1915 shows the Grace Episcopal Church, built in 1858. Undoubtedly the most historic house of worship in Whitestone and the borough of Queens, this church was formerly known as Whitestone Chapel and was built on land donated by Francis Lewis. The current structure is the renovated version from 1904. It is located at 151–17 Fourteenth Road. (Courtesy of Queens Borough Public Library, Long Island Division, Joan Kindler Postcards.)

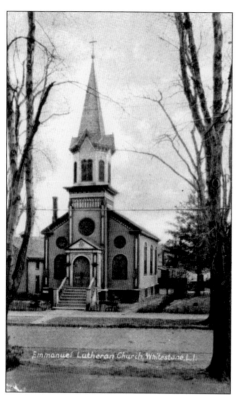

Located at 149–14 Eleventh Avenue is the Emmanuel Lutheran Church. It is the second-oldest church in Whitestone, dating back to 1896. The Emmanuel Lutheran Church also caters to Whitestone's growing Korean population by holding services performed by Korean pastors. (Courtesy of Queens Borough Public Library, Long Island Division, Joan Kindler Postcards.)

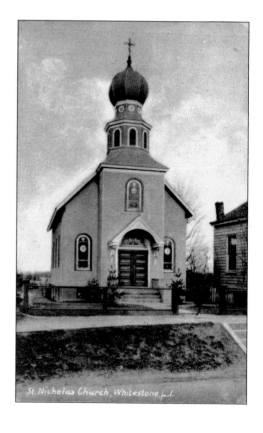

Built in 1919 on Clintonville Street, the St. Nicholas Orthodox Church is attended by people of the Russian and Eastern Orthodox faith. It was renovated in 1965, and it is this modern version that exists today. (Courtesy of Queens Borough Public Library, Long Island Division, Postcard Collection.)

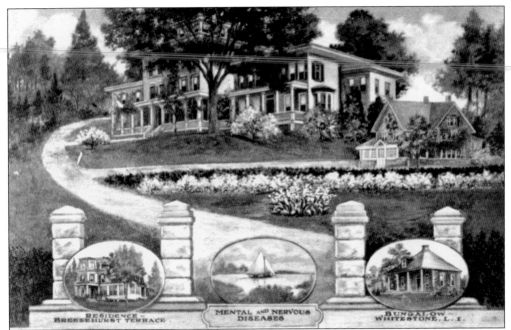

Dr. D. A. Harrison's Breezehurst Terrace sanitarium is shown in this illustrated portrait of the complex. Harrison, along with Dr. D. R. Lewis, treated people with mild mental and nervous diseases. It was established in 1890 and had a capacity of 35 patients at a time. (Courtesy of Queens Borough Public Library, Long Island Division, Joan Kindler Postcards.)

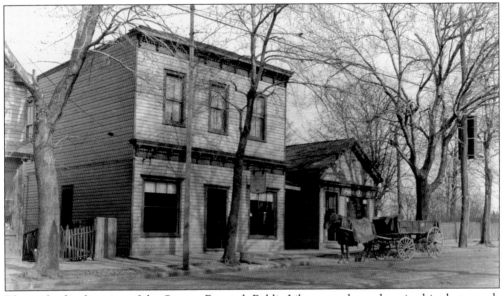

This is the first location of the Queens Borough Public Library, as shown here in this photograph from 1913. A horse pulling a carriage of supplies stands outside. (Courtesy of Queens Borough Public Library, Long Island Division, Eugene Armbruster Photographs.)

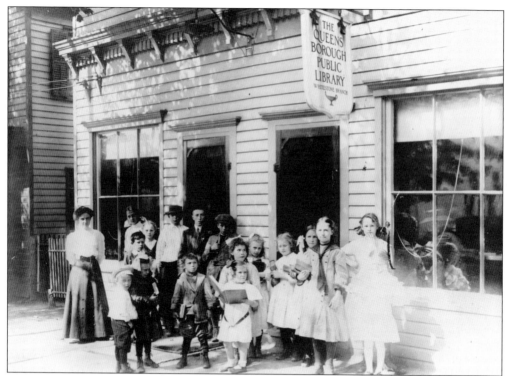

This gorgeous group photograph shows the librarian standing with a group of school children from public school 30 on what was known as reading day in the New York City public schools. (Courtesy of Queens Borough Public Library, Long Island Division, Queens Borough Public Library Records.)

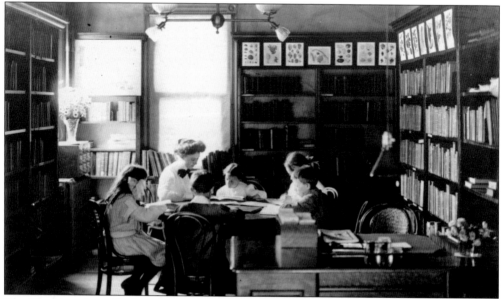

The librarian sits with these young schoolchildren as she reads them a story. Notice the gas lamps suspended from the ceiling. (Courtesy of Queens Borough Public Library, Long Island Division, Queens Borough Public Library Records.)

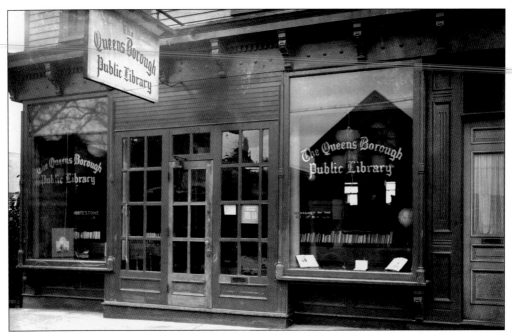

In the early 1940s, the Queens Borough Public Library relocated the Whitestone branch after the original building was torn down. This new location on 150th Street was one block north of the Cross Island Expressway. (Courtesy of Queens Borough Public Library, Long Island Division, Queens Borough Public Library Records.)

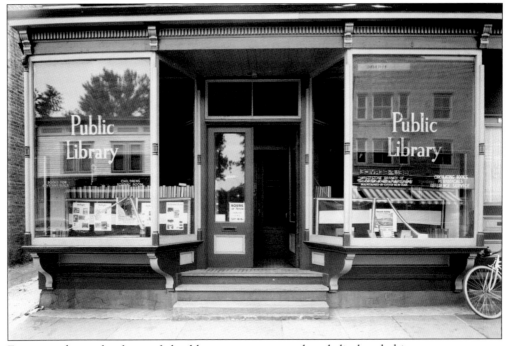

Five years later, the front of the library was renovated and displayed this new appearance. (Courtesy of Queens Borough Public Library, Long Island Division, Queens Borough Public Library Records.)

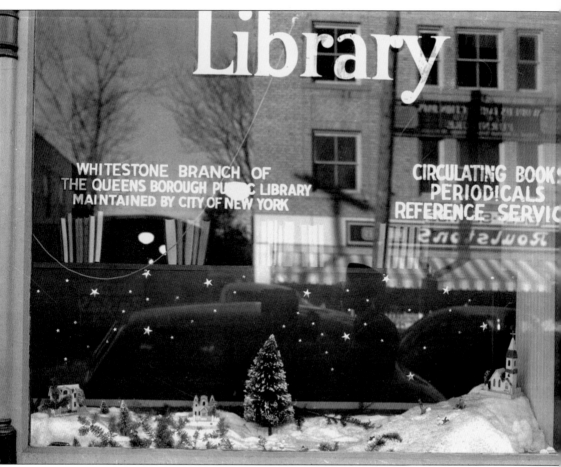

This close-up of the front window shows a Christmas display in the winter of 1945. (Courtesy of Queens Borough Public Library, Long Island Division, Queens Borough Public Library Records.)

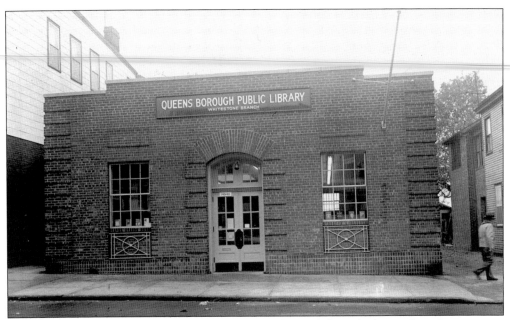

In the 1950s, the Queens Borough Public Library relocated the Whitestone branch, yet again, to Fourteenth Avenue into an old brick building that had served as a trolley barn years before. This explains the building's industrial look, as opposed to the elegant early-20th-century style architecture of the previous two. (Courtesy of Queens Borough Public Library, Long Island Division, Queens Borough Public Library Records.)

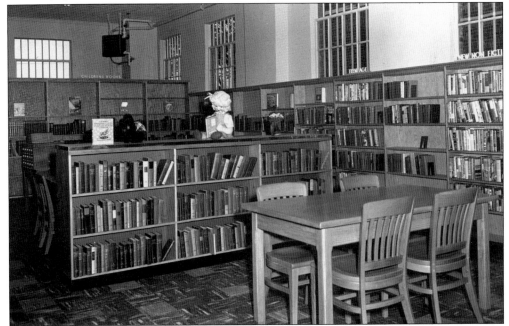

The inside of the library shows a more modern setting. Books on the shelves are ordered according to the Dewy decimal system. On the ceiling, one can see that halogen bulbs have replaced gas lamps and an electric heater is suspended in the rear. (Courtesy of Queens Borough Public Library, Long Island Division, Queens Borough Public Library Records.)

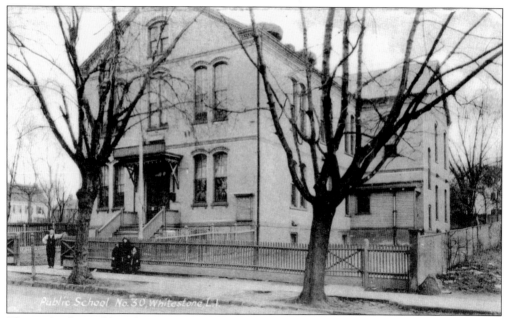

This is the first public school in Whitestone, public school 30, in the year 1910. In front of the school are some children and, most likely, the schoolmaster. The school lasted only a few years before being torn down and relocated due to the fact that the city was building more modern-day school buildings. (Courtesy of Queens Borough Public Library, Long Island Division, Postcard Collection.)

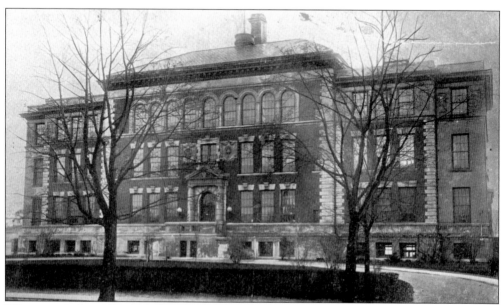

Whitestone's first official modern day school, public school 79, is shown here in this postcard photograph from 1920. (Courtesy of Queens Borough Public Library, Long Island Division, Postcard Collection.)

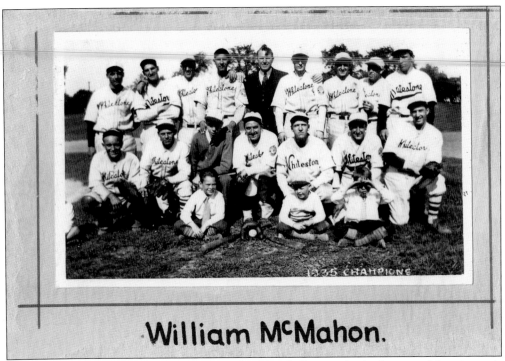

William McMahon.

William McMahon managed Whitestone's official baseball team. At the bottom of the picture, it states that this team photograph is of the 1935 champions. (Courtesy of Gleason Funeral Home.)

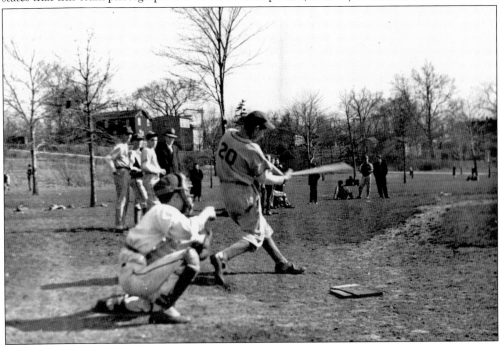

The Whitestone team is in action in this 1938 photograph. The playing field was located on 154th Street. It is near this field that the Whitestone Shopping Center currently stands. Notice how close the spectators are to the players. (Courtesy of Ralph's Barber Shop.)

The local football team, the Whitestone Shamrocks, is shown in this group photograph. The date of this team picture is unknown. Everyone looks so young and healthy. (Courtesy of Gleason Funeral Home.)

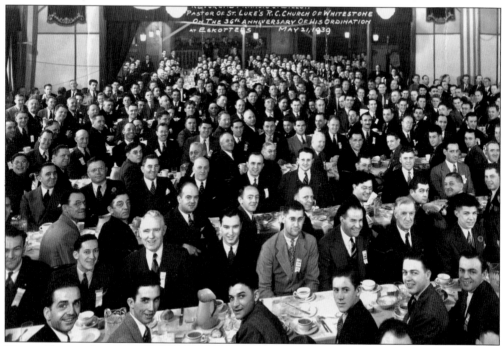

Pictured here is the testimonial breakfast for the Reverend Francis J. Dillon, pastor of St. Luke's Roman Catholic Church of Whitestone. This reception was given for the 36th anniversary of his ordination on May 21, 1939. (Courtesy of Gleason Funeral Home.)

Six

CELEBRITIES

One of the most fascinating additions to the population of Whitestone was the presence of the first movie stars of the silver screen. Mary Pickford, Charlie Chaplin, and Rudolph Valentino enjoyed the seaside atmosphere and built beautiful homes that were used as country houses during the summer or if they were making a movie in nearby Astoria, at Astoria Studios.

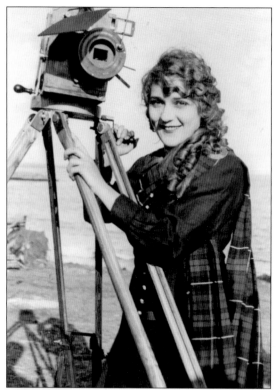

One of cinema's most powerful icons, Mary Pickford was born Gladys Smith on April 8, 1892, in Toronto, Canada. In 1909, at the age of 17, she was spotted by famous director D. W. Griffith. He hired Pickford, and before the year was out, she had made 42 films. Pickford became cinema's first female star. To be close to where she worked, Pickford lived in Whitestone from 1909 until 1911. In 1919, Pickford, Griffith, Douglas Fairbanks, and Whitestone resident Charlie Chaplain created United Artists. By this time, Pickford was earning $150,000 a year, making her one of the world's richest and most successful women. In 1920, she married Douglas Fairbanks. For her role in *Coquette* (1929), Pickford won an Academy Award. Her most famous film to date is the silent classic *Poor Little Rich Girl* (1917). Pickford was an actress and producer of talent and vision. She was given an Honorary Oscar in 1976. She died on May 29, 1979, at age 87. (Author's collection.)

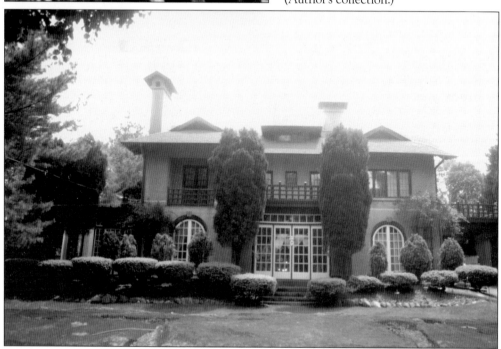

The home of Mary Pickford was built around 1900. It is an enormous mansion with an equally large front lawn. Because of its size, the lawn was used by Pickford to throw celebrity parties. (Author's collection.)

Clearly one of the most recognizable people in the world, Charlie Chaplin was born in London on April 16, 1889. At the age of 21, he came to New York, where the young vaudeville actor was signed to a motion picture contract with Keystone films. In just two years, Chaplin became cinema's first leading comedy actor. Chaplin made part of his silent films at Astoria Studios in Queens. Fellow artist Mary Pickford introduced Chaplin to the beautiful and serene environment of Whitestone. Chaplin lived at the Beechhurst Towers hotel during his demanding shooting schedule. His most famous films include *The Kid* (1921), *The Gold Rush* (1925), *City Lights* (1931), and *Modern Times* (1936). (Author's collection.)

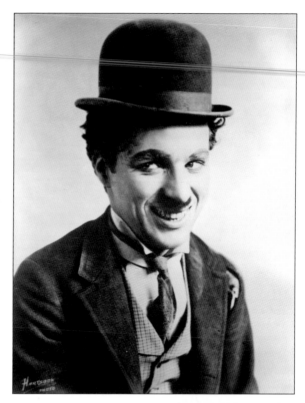

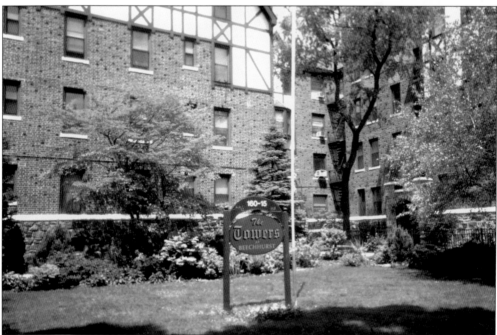

The Beechhurst Towers located at 160–15 Powells Cove Boulevard was built as a hotel for the actors of the silent era in 1920. Chaplin lived here while filming at Astoria Studios. (Photograph by Jason D. Antos.)

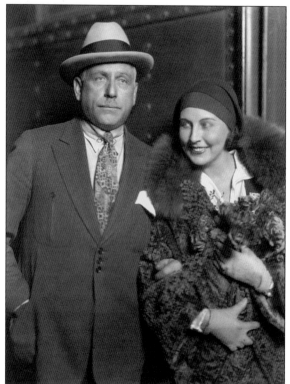

Arthur Hammerstein was a successful Broadway producer and songwriter. His nephew Oscar Hammerstein II wrote the music for famous musicals such as *The King and I* (1951). Arthur Hammerstein is best known for his musical *Wildflower* (1923) and his No. 1 hit song "Because of You." He is pictured here with his wife Dorothy Dalton, who was a famous actress from the silent era. She starred in 60 films between 1917 and 1924. (Courtesy of CGC Vintage Photography.)

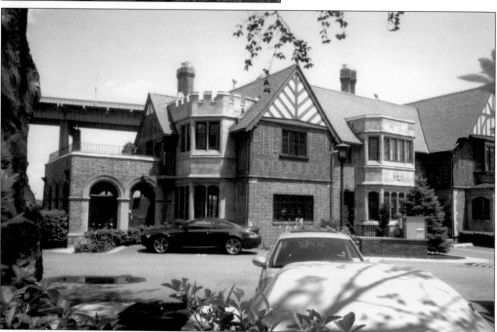

The abandoned estate became a hangout for local gangs, and in 1994, it was burned down. In 2000, it was declared a national landmark. This photograph shows the Hammerstein estate in its current form. It has been totally renovated, restored, and divided into duplexes. (Photograph by Jason D. Antos.)

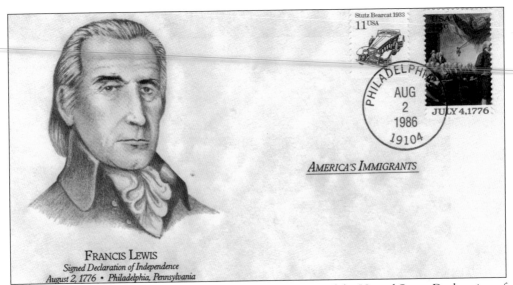

FRANCIS LEWIS
Signed Declaration of Independence
August 2, 1776 • Philadelphia, Pennsylvania

Born in Wales on March 21, 1713, Francis Lewis was a signer of the United States Declaration of Independence as a representative of New York. He was also elected to the Continental Congress. (Author's collection.)

All that remains to this day is the front gate leading to Lewis's property. Overgrown and deteriorated, the Francis Lewis homestead was the site of one of the most infamous moments of the Revolutionary War. In the autumn of 1776, the British attacked his farm and burned his house to the ground. They also took his wife, Elizabeth, prisoner. Due to the horrible prison conditions, Elizabeth became very ill and never recovered. She died soon after. (Photograph by Jason D. Antos.)

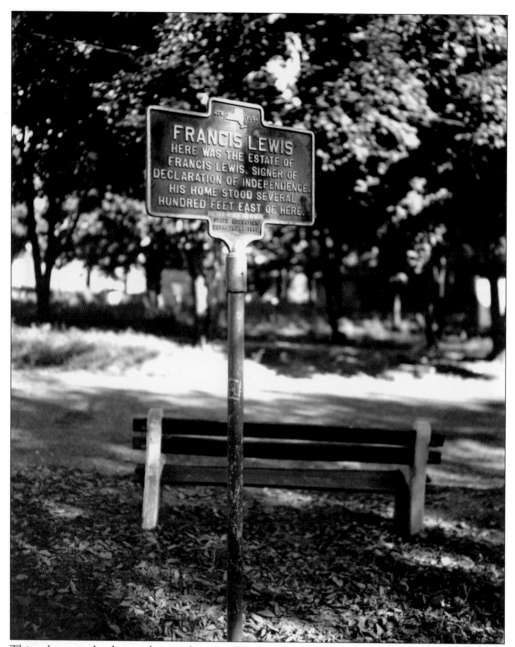

This photograph shows the marker for Francis Lewis Park, which is located below the Bronx-Whitestone Bridge. The park itself is just off of Parsons Boulevard and Third Avenue. (Courtesy of Queens Borough Public Library, Long Island Division, Borough President of Queens Collection.)

American poet, essayist, and journalist Walt Whitman was born on May 31, 1819, on Long Island in the town of Huntington. Born into a family of nine children, Whitman became editor of the *Long Islander* newspaper at the age of 19. Whitman spent many years in the boroughs of Brooklyn and Queens. It was here in Whitestone that Whitman gave Sunday sermons and wrote poetry by the waterfront. He wrote in his diary, "every morning, I am kissed by the sun coming through my window by the bay of Whitestone." In 1855, he published his most famous book, a collection of poetry titled *Leaves of Grass*. Whitman died in Boston in 1892. (Author's collection.)

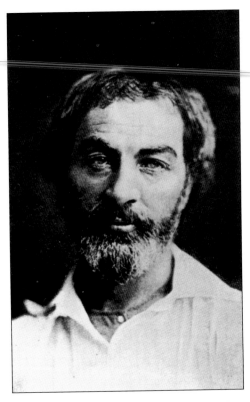

This is the boardinghouse that Whitman stayed at while visiting Whitestone. This beautiful home is located on Clintonville Street. (Photograph by Jason D. Antos.)

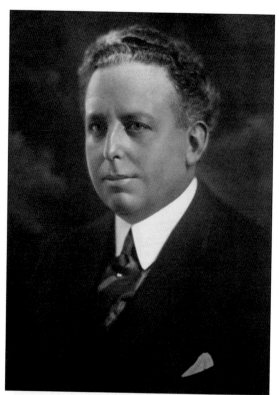

Born in Whitestone on June 3, 1885, Charles S. Colden was district attorney for Queens. The position was given to him by Franklin D. Roosevelt. In 1942, he became a justice of the state supreme court, where he served for 13 years. In 1938, he successfully petitioned the City of New York to create Queens College and also helped create the Bowne House Historical Society. Colden also was a member of the vestry at Grace Episcopal Church. He died in Whitestone on September 14, 1960. (Courtesy of Queens Borough Public Library, Long Island Division, Borough President of Queens Collection.)

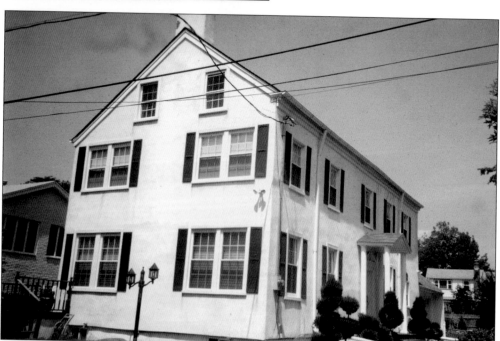

The home of Colden was also the former homestead of Francis Lewis. Originally built in 1763, the home underwent dramatic changes in 1926 when Colden sold the home to Charles H. Smeff, a sugar refiner. It is located at 2–11 147th Street. (Photograph by Jason D. Antos.)

Paulette Goddard was born Pauline Marion Levy on June 3, 1911, in Whitestone. At the age of five, she became a child fashion model. She was married at the age of 16 to Broadway writer Edgar James for four years. In 1931, Goddard went to Hollywood to begin a career in motion pictures. It was there that she met Charlie Chaplin. They married in 1936 and divorced in 1942. She starred in Chaplin's film *Modern Times* (1936) and was considered for the role of Scarlett O'Hara in *Gone With the Wind* (1939). In 1943, she reached the pinnacle of her fame when she earned an Academy Award nomination for Best Actress in a Supporting Role for the film *So Proudly We Hail* (1943). She died on April 23, 1990. (Author's collection.)

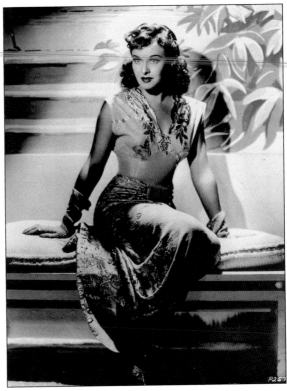

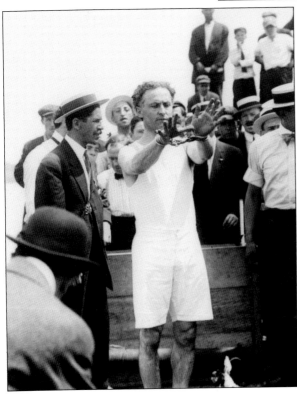

Born Erik Weiss in Budapest, Hungary, in March 1874, Harry Houdini was the world's greatest escape artist. His father was a rabbi and, in 1878, moved his family to Wisconsin to head up the Zion Reform Jewish Congregation. In 1887, the family moved to New York City where young Weiss began practicing magic. In 1891, he became a professional magician but did not reach fame until 1913, when he changed his name. His most famous act was the Chinese water torture cell, in which he was suspended upside-down in a locked glass and steel cabinet full of water while handcuffed. Houdini died on Halloween in 1926. He is buried in Queens. His house, located on Powells Cove Boulevard, was demolished in 1995. (Author's collection.)

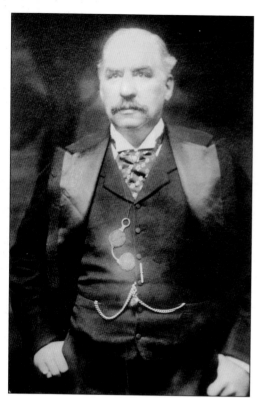

Born in 1837 to rich bankers, John Pierpont Morgan is the founder of J. P. Morgan and Company, one of the largest banking and financial service institutions in the United States. The company was used to finance the New York, New Haven and Hartford Railroad as well as United States Steel Corporation. In 1895, his bank supplied the United States government with $62 million in gold. In 1968, his bank merged with Chase Manhattan Bank. Today the bank serves more than 90 million customers and employs approximately 170,000 people. Morgan died in 1913. (Courtesy of RMP Archive/George Grantham Bain Collection.)

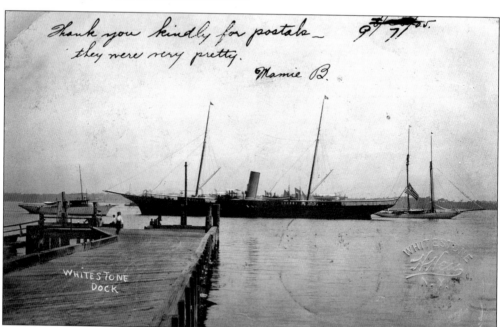

Thank you kindly for postals — they were very pretty.
Mamie B.
9/7/05.

WHITESTONE DOCK

This postcard dated September 7, 1905, shows the private yacht of J. P. Morgan, the *Corsair*, sailing through Flushing Bay near the Whitestone Yacht Club. American financier and banker, Morgan was one of the wealthiest men in America. He died eight years after this photograph was taken. (Courtesy of H. Hess.)

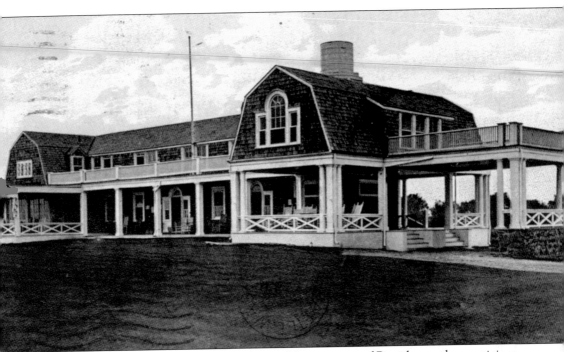

Located on the outskirts of Whitestone in the neighboring town of Bayside was the prestigious Oakland Golf Club, shown in this postcard dated June 18, 1908. Rudolph Valentino and baseball great Babe Ruth were members. The club is long since gone; it was torn down to build the approach for the Throgs Neck Bridge. (Author's collection.)

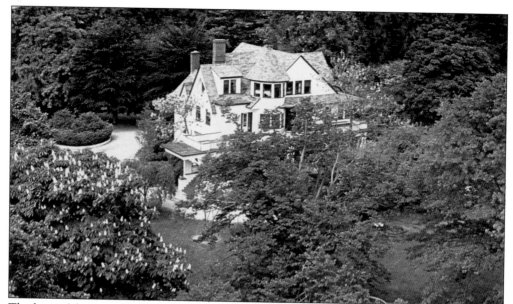

The beautiful estate of Harvey S. Firestone, founder of Firestone Tires, was located on Powells Cove Boulevard at Cryder's Point on the Long Island Sound. The home was occupied by his family until his death in 1932. The home was turned into a bed-and-breakfast named Michel-on-the-Sound. It featured a deluxe swimming pool, tennis court, and private beach. It was demolished in 1964 to make room for a 20-story apartment building called the Cryder House. (Author's collection.)

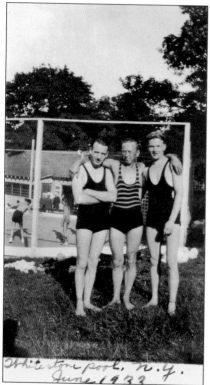

Three unknown men pose for this photograph, dated June 1933. The location is the property of the Firestone estate, which was used as a part-time health clinic. In the background, people can be seen playing tennis by the clubhouse. (Author's collection.)

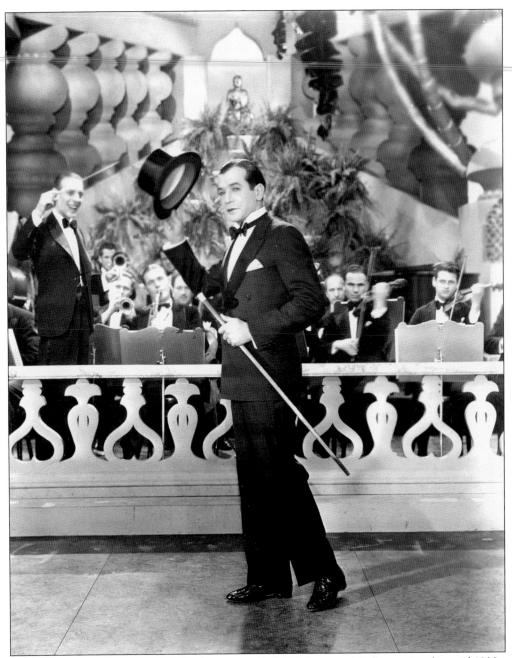

Actor, singer, and pilot Harry Richmann called Whitestone his home in the mid-1930s. Richmann was the original recording artist of Irving Berlin's "Puttin' on the Ritz." He is pictured here performing the musical number in a still promotional photograph from the movie of the same name. Richmann will forever be remembered as the man who botched the first round-trip Atlantic flight when he panicked and dumped all the fuel into the Atlantic Ocean causing the plane to crash in New Jersey, just 50 miles from completing the round-trip. Luckily, no one was hurt. (Author's collection.)

Harry Richman [signature]

at Home
BEECHHURST
LONG ISLAND

November 2, 1936.

Dear Ruth Maurer:-

 Many thanks for your kind note.
The sentiments you express for my humble
efforts are indeed inspiring, and believe
me, they hit the right spot.

 I was more than pleased to know
you enjoyed my songs on the Rinso program.
I have just concluded a series of transcrip-
tions that will be released over the "air"
in the near future. Your local paper will
give you the hour and station. I hope I
may count you as one of the audience, and
your comments or criticisms will be welcom-
ed.

 Wishing you lots of happiness
ahead, I am,

 Yours, very sincerely,

[signature]

In this rare letter to Ruth Maurer dated November 2, 1936, Harry Richmann replies to the young fan's letter saying, "many thanks for your kind note." In the upper right-hand corner is the official letterhead, which reads, "At home. Beechhurst, Long Island." (Author's collection.)

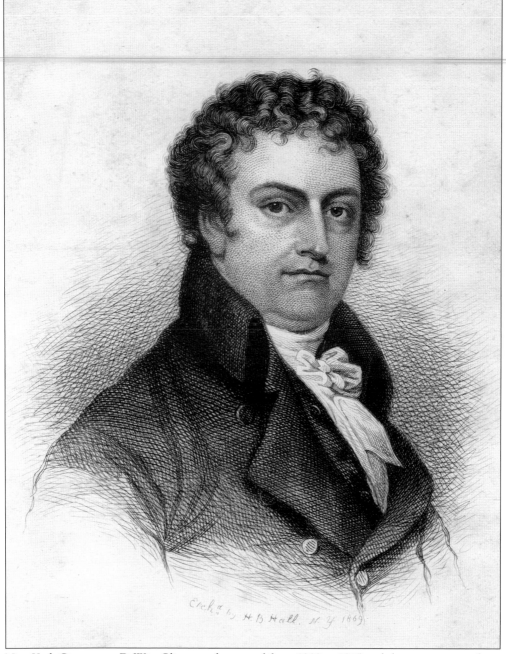

New York City mayor DeWitt Clinton, who served from 1803 to 1815 and then as governor from 1817 to 1823, was a proud Whitestone resident. To show their support, the people changed the name to Clintonville in his honor. However, once he was out of office, a battle began to change the name back to Whitestone. It was officially changed back in 1854 when a United States post office was established. (Author's collection.)

This was a popular place for celebrities to stay during their shooting schedule at Astoria Studios. This building also housed the post office seen on the bottom of page 39. It is located on 150th Street and the Cross Island service road. (Photograph by Jason D. Antos.)

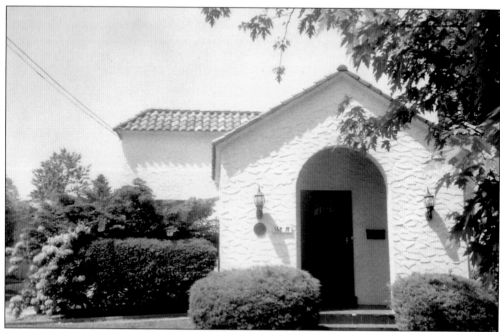

Pictured here is the summer home of Harry Richmann. Composed in a Mediterranean style, this home is capped with a brilliantly colored terra-cotta mission-tile shingle roof and balconies offering access to a garden setting. The home has been marked by the Queens Historical Society. (Photograph by Jason D. Antos.)

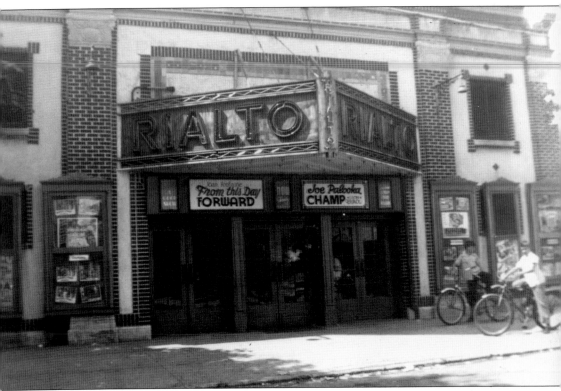

The Rialto Theater was located on 149–15 Fifteenth Road. The posters on the front advertise the films *Gilda*, which starred Glen Ford and Rita Hayworth, and *From This Day Forward*, which starred Joan Fontaine. Two young boys stand with their bicycles just outside the entrance in this 1946 photograph. The Rialto closed its doors in 1960 and became a bingo parlor. In 1966, the building became the headquarters for the Dwarf Giraffe Athletic League. Never again has there been a movie palace in the town of Whitestone. (Courtesy of Queens Borough Public Library, Long Island Division.)

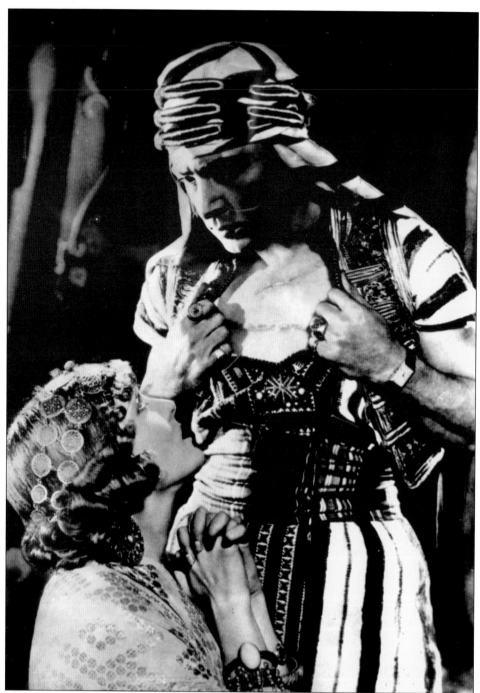

Cinema's first leading man, male sex symbol, and Whitestone resident Rudolph Valentino emigrated from Italy in 1913, at the age of 18. After working as a busboy for several years, Valentino broke into show business after traveling to Hollywood in 1917. His most famous role was as Sheik Hassan in *The Sheik* (1921) and the sequel *The Son of the Sheik* (1926), which was released after his sudden death at the age of 31. His funeral in New York was attended by over 80,000 people. (Author's collection.)

Seven

WHITESTONE AND THE MODERN AGE

The story of this small hidden Queens neighborhood cannot conclude without talking about its modern-day contributions. In this chapter, the Bronx-Whitestone and Throgs Neck Bridges will be examined. The Throgs Neck Bridge was named after John Throckmorton, a Dutch settler who started one of the first free religious societies in what was then New Amsterdam.

Beginning in 1905, speculators proposed the construction of a bridge spanning the East River, for the purpose of connecting Whitestone to Ferry Point in the Bronx. In 1929, the Regional Plan Association revived plans for such a bridge. Robert E. Moses received authorization to build the Bronx-Whitestone Bridge from the New York State legislature in April 1937, and construction commenced on June 1, 1937. Moses demanded that the bridge be ready in time for the opening of the 1939 world's fair in April of that year. On April 29, 1939, the Bronx-Whitestone Bridge opened to traffic. Characterized by its art deco design created by Othmar, the bridge carries approximately 110,000 vehicles per day. Also, this chapter will examine some dramatic changes of the landscape in Whitestone. The comparisons are shocking as Whitestone heads well into the 20th century and beyond.

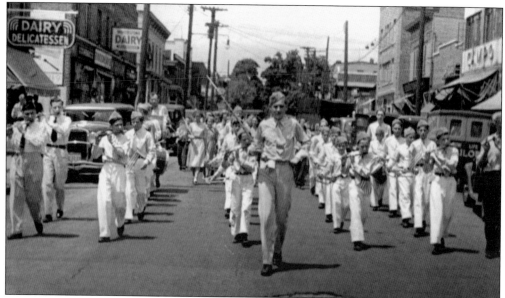

Shown here is the Whitestone Fourth of July parade down the main drag of 150th Street in 1939. The band marches proudly as Whitestone moves closer to the second half of the 20th century. Notice the beautiful 1930s Phantoms parked at the curb on the left. Next to them are two delicatessens, including Whitestone Dairy. To the right in the far background is Harpell Chemists, which was started in 1906. Freddy's Pizzeria is to the left, at the farthest end of the block. (Courtesy of Gleason Funeral Home.)

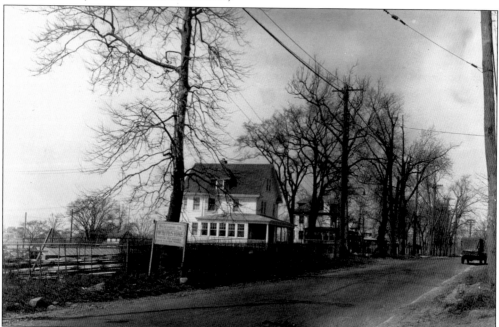

"Welcome to Whitestone! Follow the Arrows and See the Town!" says the new welcome sign at the entrance of the town near Third Avenue. This photograph, from 1937, was taken just days before construction on the Bronx-Whitestone began. (Courtesy of Queens Borough Public Library, Long Island Division, Eugene Armbruster Photographs.)

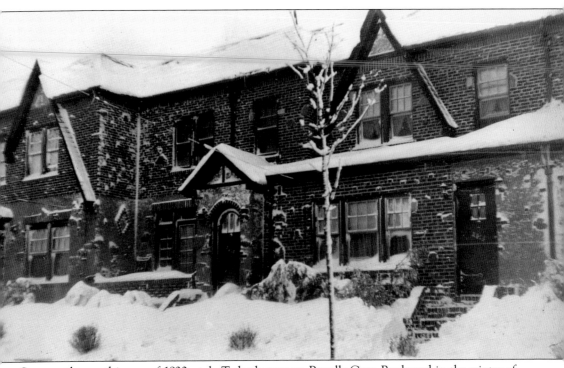

Snow settles on this row of 1930s-style Tudor homes on Powells Cove Boulevard in the winter of 1934. Whitestone, because of its northern location, was almost never plowed. (Author's collection.)

The armory located at 150–17 and Sixth Avenue was built in 1933. Used as a temporary police station, it was part of the Fort Totten army base. The armory was used to house weapons and vehicles. It still remains to this day, where it is used as a place for athletic events such as basketball games and serves as a post for the New York State Division of the United States National Guard. (Photograph by Jason D. Antos.)

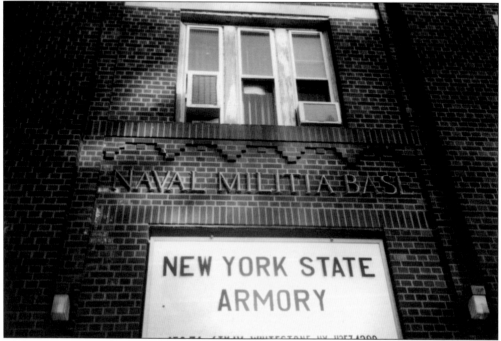

The title of the building states that it is a naval militia base and has been designated a New York State armory. (Photograph by Jason D. Antos.)

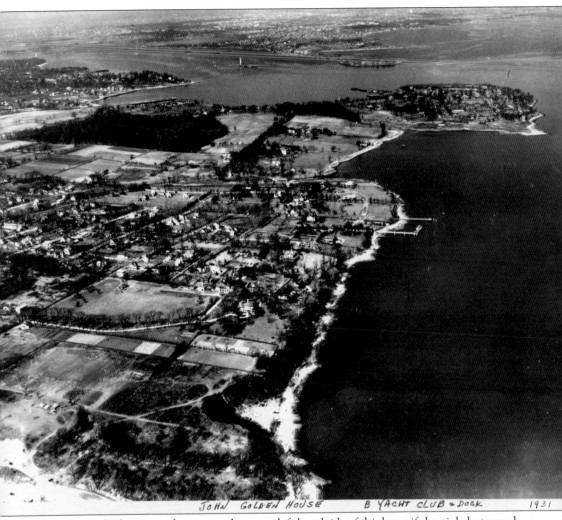

JOHN GOLDEN HOUSE B YACHT CLUB & DOCK 1931

The territory of Whitestone dominates the upper left-hand side of this beautiful aerial photograph from 1931. Notice the absence of the Bronx-Whitestone and Throgs Neck Bridges. Along the coastline on the right side of this picture is where the Cross Island Expressway will be built. The roadway provides access to both bridges. (Courtesy of Bayside Historical Society.)

Here construction on the Cross Island Expressway begins. The tracks of the Whitestone line have been dug up. In this photograph from 1938, the pathway of the old Whitestone LIRR is removed to make way for the new expressway that will service the Bronx-Whitestone Bridge. In the background on the right is the apartment building, the Whitestone, as shown earlier on the top of page 92. (Author's collection.)

This picture shows more homes being moved to make way for the service road of the Cross Island Expressway. Homes are placed on platforms and then are slid along tracks. These structures will only be moved several yards, which is just enough space for the two-lane road. The sign reads, "United States Works in Progress Administration. Project G5-97-100. Sponsored by Honorable George U Harvey – President, Borough of Queens." (Courtesy of Queens Borough Public Library, Long Island Division, Borough President of Queens Collection.)

The firehouse of the 144 Hook and Ladder Company is also affected by the construction, as it to is moved to make room for the service road that will lead to the Cross Island Expressway and the right-of-way for the Bronx-Whitestone Bridge. Notice the tracks underneath the foundation that were used to raise the entire structure and move it from its previous spot. Its new location is only several yards away. (Courtesy of Queens Borough Public Library, Whitestone Branch.)

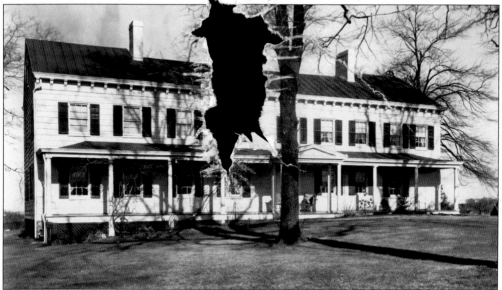

This is the home of the Powell family. Edwim Powell lived here before giving it to his daughter Mary Roe. This estate was located west of Fourteenth Avenue, near Parsons Boulevard. This beautiful mansion was leveled to create the entrance ramp for the Bronx-Whitestone Bridge. (Courtesy of Queens Borough Public Library, Long Island Division, Borough President of Queens Collection.)

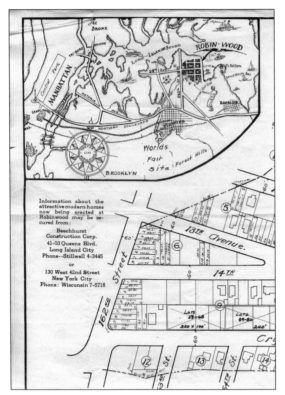

Robinwood, another subdivision of Whitestone, is shown here in its beginning stages. In the upper left-hand corner is a detailed overview of Whitestone, which shows the absence of both the Bronx-Whitestone and Throgs Neck Bridges. (Courtesy of Bayside Historical Society, Dayton Collection.)

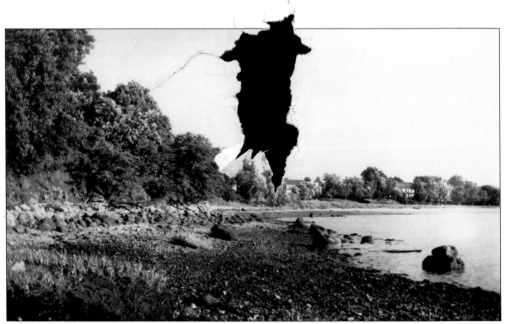

Smith's shore is shown here once again; this time the estate has been torn down. This picture was taken on a field trip used to map out the construction for the entrance of the Bronx-Whitestone Bridge. (Courtesy of Queens Public Borough Public Library, Long Island Division, Ralph Solecki Photographs.)

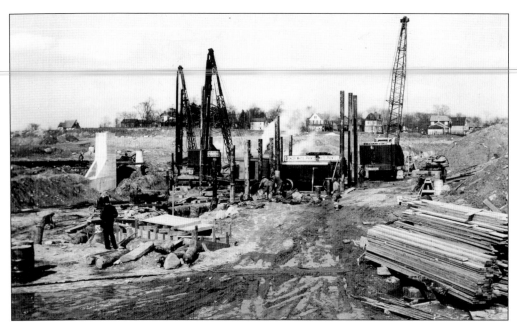

This image shows construction beginning on the fourth-largest suspension of its time, the Bronx-Whitestone Bridge. This photograph, taken on July 1, 1937, shows workers building the foundation for the bridge's approach near Parsons Boulevard. A dozen homes were torn down in order for building to begin. The occupants were given $30,000 each by the City of New York to vacate their property. (Courtesy of Spencer, White, and Prentis.)

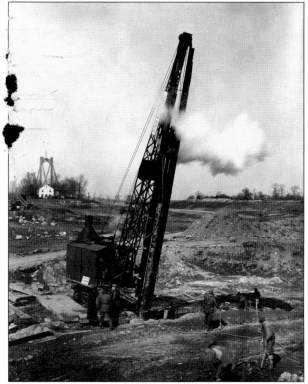

This photograph taken on March 8, 1939, seven weeks before the grand opening, shows the bridge nearly completed. This large crane owned by Spencer, White, and Prentis Construction digs deep into the ground, creating the foundation for the approach off of the Whitestone Expressway. In the background, near the bridge, is the last surviving home. It will be destroyed to complete the expressway and approach. (Courtesy of Spencer, White, and Prentis.)

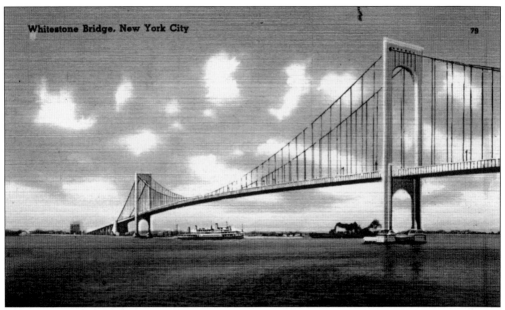

This postcard shows the final conception of the Bronx-Whitestone Bridge just before construction commenced in April 1938. (Author's collection.)

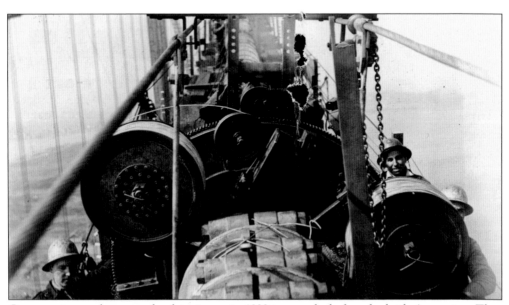

Construction workers pose for this picture in 1939 just weeks before the bridge's opening. They surround a machine called a kelly wagon, which was used for the placement of the cable bands. (Courtesy of American Bridge.)

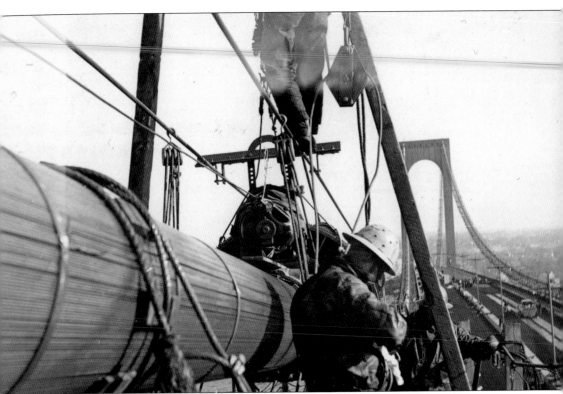

Fending off the cold, harsh winter in early 1939, workers fasten bolts and tie up cables on the almost completed Bronx-Whitestone Bridge. (Courtesy of American Bridge.)

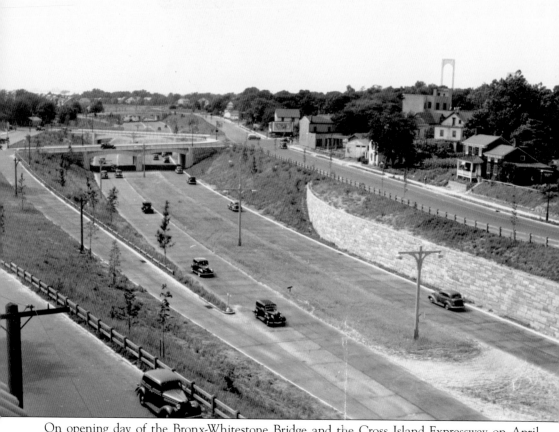

On opening day of the Bronx-Whitestone Bridge and the Cross Island Expressway on April 29, 1939, cars are already making good use of the two lanes in this extraordinary scene. Notice the option for a U-turn made available at the bottom of the photograph, as well as the wooden streetlamps. The divider was only a small grassy hill. (Courtesy of Queens Borough Public Library, Long Island Division, Chamber of Commerce of the Borough of Queens Collection.)

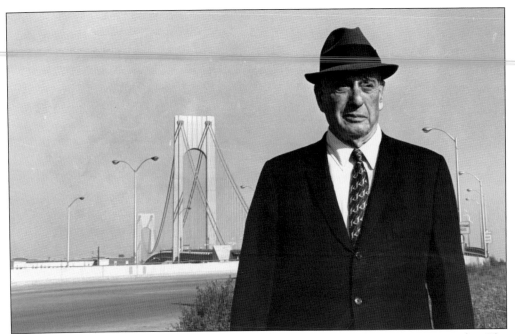

Robert Moses stands proudly in front of the Bronx-Whitestone Bridge on its opening day. The master builder of 20th-century New York City was quoted, "Here if anywhere, we have pure functional architecture." (Courtesy of Queens Borough Public Library, Long Island Division, Borough President of Queens Collection.)

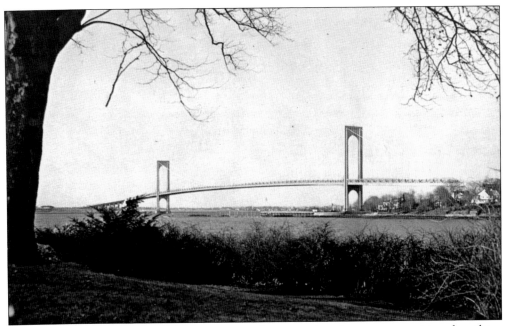

The bridge is now complete! The first review made on opening day was very positive, describing it as "a fine spun elegance of outline and detail." (Courtesy of Queens Borough Public Library, Long Island Division, Postcard Collection.)

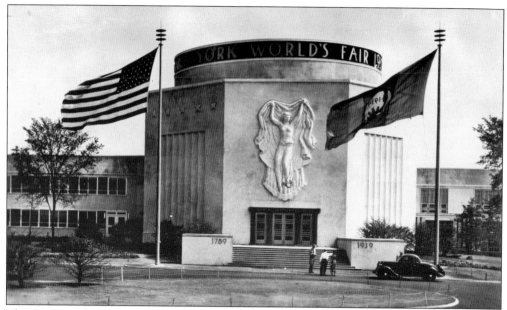

The 1939 world's fair began one day after the opening of the Bronx-Whitestone Bridge, which was built as part of the New York exhibition and served to support traffic going to and from the fair. (Author's collection.)

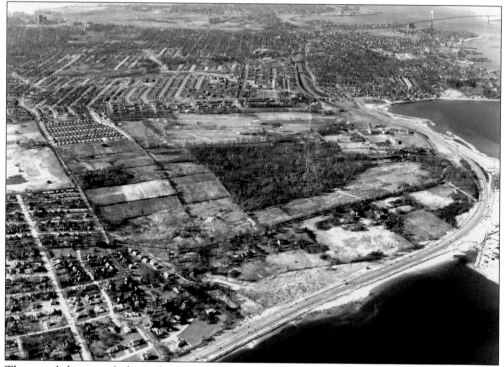

This aerial photograph shows the newly built Cross Island Expressway running along the seashore. This is a drastic change in comparison to the scene on page 99. One can follow the expressway all the way to the Bronx-Whitestone Bridge, located in the top portion of the picture. (Courtesy of Bayside Historical Society.)

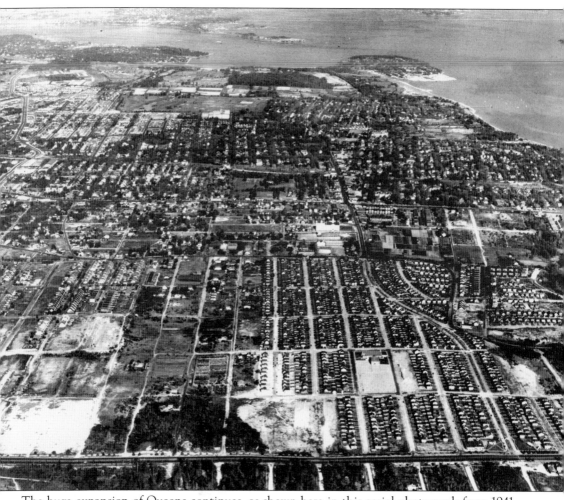

The huge expansion of Queens continues, as shown here in this aerial photograph from 1941. The town of Bayside is in the lower portion, while Whitestone makes up for the topmost section of this now heavily populated borough. (Courtesy of Bayside Historical Society.)

This image from 1955 shows Utopia Parkway and Fourteenth Avenue, looking north. This was a popular fishing spot for locals and overlooked the Long Island Sound. Today the Throgs Neck Bridge dominates the background on the right side. Note the old-fashioned Victorian streetlamp on the left. (Courtesy of Queenspix.com.)

This street view from 1954 shows the small subdivision of Beechhurst. This small section was named for its plentiful amount of beech trees, *hurst* meaning many in German. In the distance are the several stores that make up the downtown. (Courtesy of Queenspix.com.)

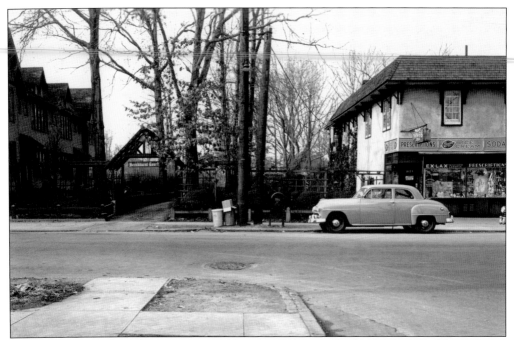

The small village of Beechhurst is pictured here in 1954. In the background is Beechhurst Court, a small community that has long since vanished when the area was cleared to create what is now Twelfth Road. (Courtesy of Queenspix.com.)

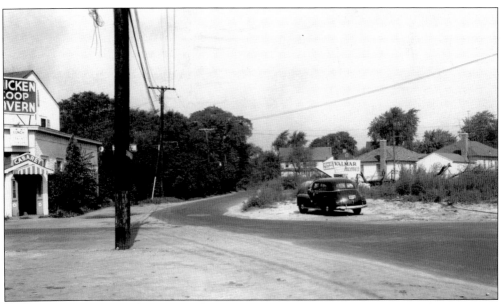

Clintonville Street and Willets Point Boulevard are shown here, looking north, in 1945. In the background is further evidence of the urbanization of Whitestone. The forest pictured here is being cleared by the Valmar Real Estate Corporation. The building on the left is the Chicken Coop Tavern and Cabaret, which burned down many years later. (Courtesy of Queenspix.com.)

Depicted here is the construction of public school 193 in the winter of 1953 on Eleventh Avenue through the wooded area just opposite the school. (Courtesy of Queens Borough Public Library, Long Island Division, Borough President of Queens Collection.)

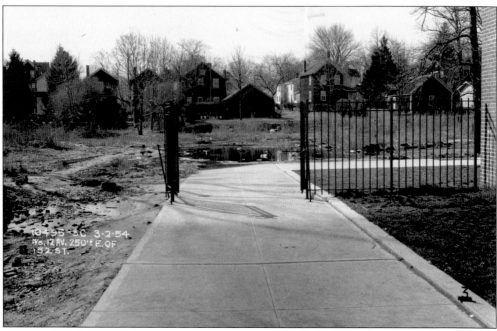

The woods and wet marsh continue into the rear of the new school grounds. The trees will be cleared away to create new homes and streets. This image serves as a reminder of how rural this town once was. (Courtesy of Queens Borough Public Library, Long Island Division, Borough President of Queens Collection.)

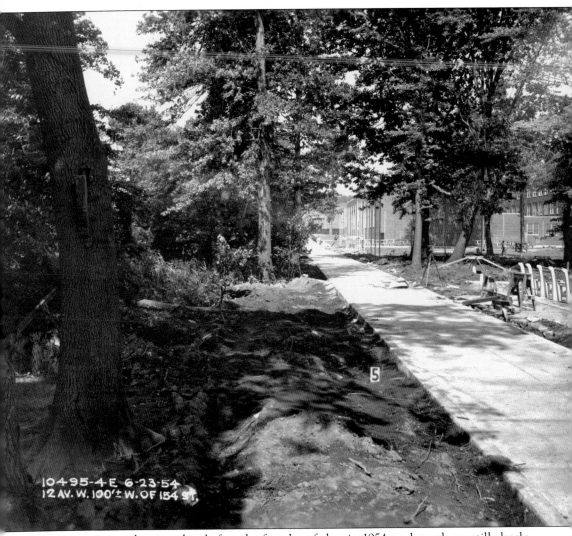

This picture was taken just days before the first day of class in 1954, and woods are still clearly visible around the grounds. Today that is all gone, and the streets surrounding the school are lined with small private homes and neatly kept lawns. (Courtesy of Queens Borough Public Library, Long Island Division, Borough President of Queens Collection.)

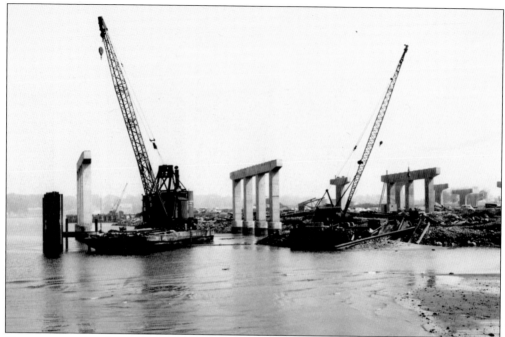

Here construction begins on the Throgs Neck Bridge in 1959. This second span to service Whitestone and the surrounding areas of Queens and the Bronx was named after John Throckmorton. (Courtesy of Bayside Historical Society.)

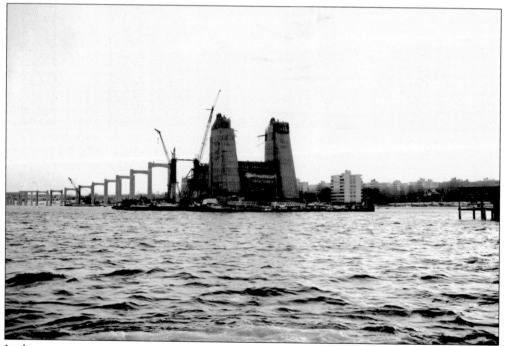

In this image, construction is beginning in the winter of 1959 on Othmar Ammann's conception. This picture shows the foundation and roadway trestle in the East River. In the background is the newly developed Levitt House apartment complex. (Courtesy of Queenspix.com.)

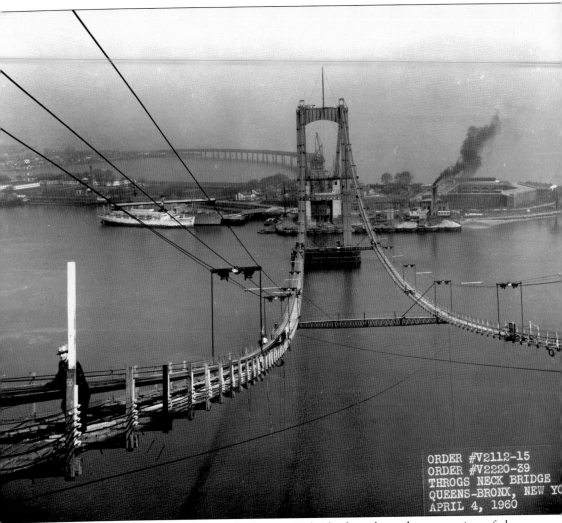

ORDER #V2112-15
ORDER #V2220-39
THROGS NECK BRIDGE
QUEENS-BRONX, NEW YO
APRIL 4, 1960

A lone construction worker makes his way across a footbridge, along the suspension of the Throgs Neck Bridge. In the background are South Bronx and Fort Schuyler, which is now part of State University of New York at Maritime. This photograph was taken on April 4, 1960. (Courtesy of American Bridge.)

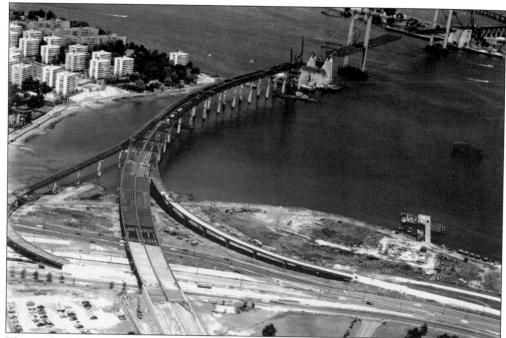

The roadway has started from either side and is slowly working its way toward the middle. This picture was taken in the summer of 1960. The entrance and exit ramps have also been built merging into the Cross Island Expressway. (Courtesy of Queenspix.com.)

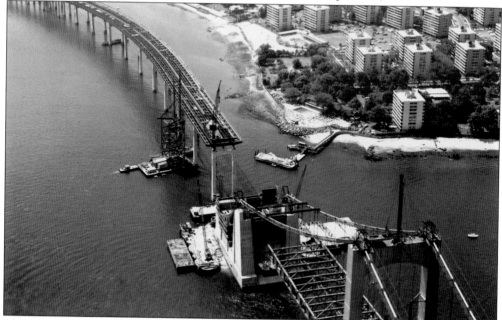

This image shows the roadway and under trestle near completion in the summer of 1960. In the background is a fantastic view of the new Whitestone. The Levitt House apartment complex, which consists of 32 buildings, is located in the background. In the center of the picture, at the water's edge, is the Arthur Hammerstein estate, which is now a catering hall and pool club. (Courtesy of Queenspix.com.)

116

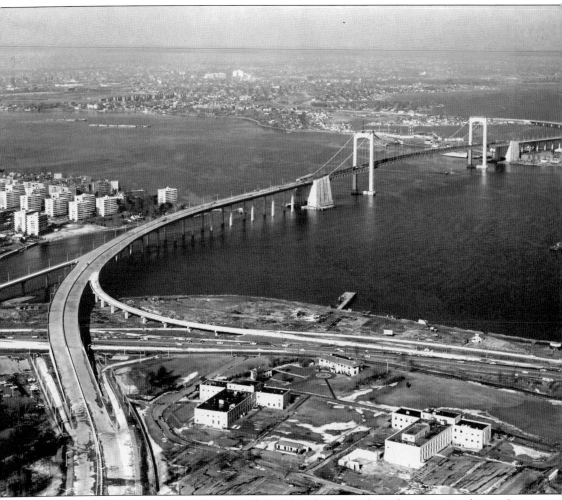

This photograph, taken in November 1960, shows the Throgs Neck Bridge near completion. It will have its grand opening on January 11, 1961. (Courtesy of Queenspix.com.)

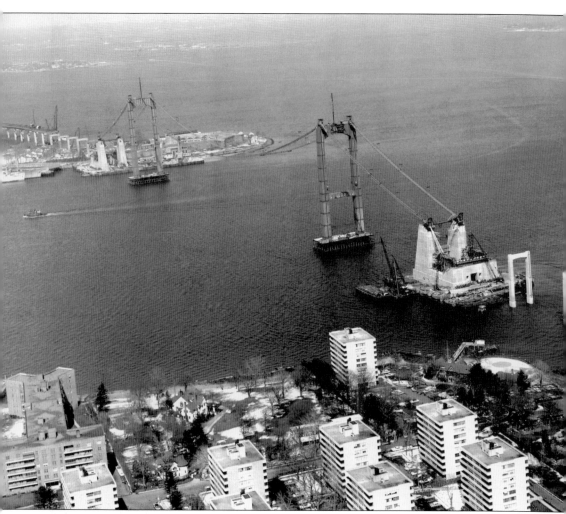

Located at the water's edge, Cryder's Point is named after W. W. Cryder, who was a Dutch farmer who owned the entire property in the late 1800s. This photograph, taken in the winter of 1959, shows the newly constructed Levitt Houses. In the lower left-hand corner are the Cryder's Point Apartments, which are named after the land's previous owner. If one looks closely, there are three mansions among these new modern-day brick and concrete structures. Just below the foundation of the bridge is the Hammerstein estate and in the lower left is the estate of tire king Harvey Firestone. The smaller home located below the main house was a day care home for children. Today this is the location of Cryder House Apartments, a 20-story building. This area can be found located at the corner of 166th Street and Powells Cove Boulevard. (Courtesy of Queenspix.com.)

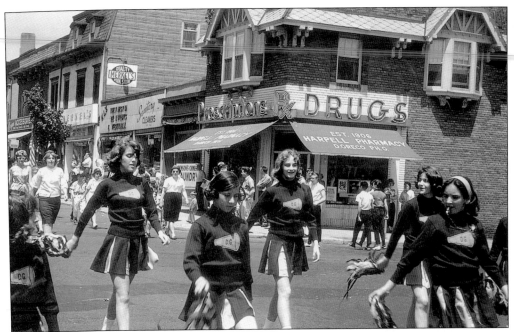

This is a parade for the Dwarf Giraffe football team on July Fourth 1964. Behind the marching cheerleaders is Harpell Chemists, which has serviced Whitestone since 1906. (Courtesy of Harpell Pharmacy.)

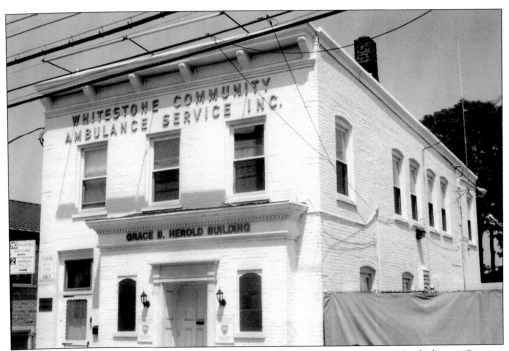

Started in the 1930s by Grace B. Herold, the Whitestone Community Ambulance Service provides medical attention and is the oldest public service in the neighborhood. (Photograph by Jason D. Antos.)

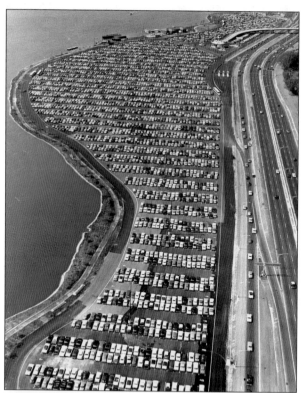

This enormous parking lot was built on the outskirts of Whitestone to accommodate all the people attending the world's fair. A special shuttle bus took people from this location to the fairgrounds. (Author's collection.)

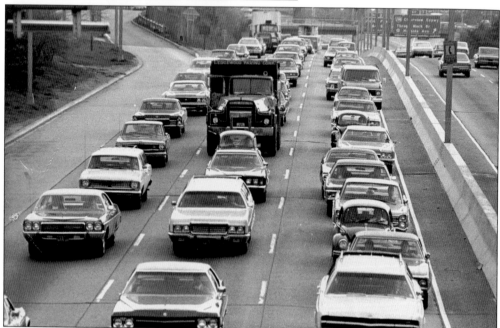

The growth of the borough is evident in this 1973 photograph of a traffic jam on the Long Island Expressway. The exit sign in the background on the right is for the Throgs Neck Bridge. The bridge was built to alleviate traffic like this on the Cross Island Expressway and into the Bronx. (Author's collection.)

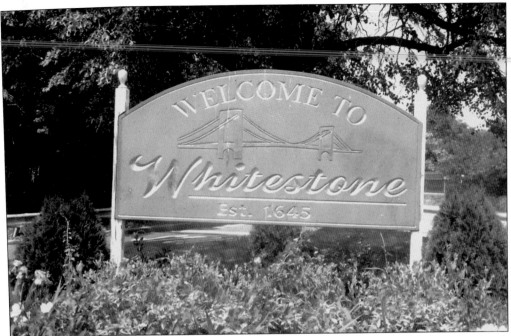

"Welcome to Whitestone, Est. 1645," reads the sign located at the entrance of the neighborhood. Behind it is the entrance ramp to Cross Island Expressway and the only exit leading from and into the town. (Photograph by Jason D. Antos.)

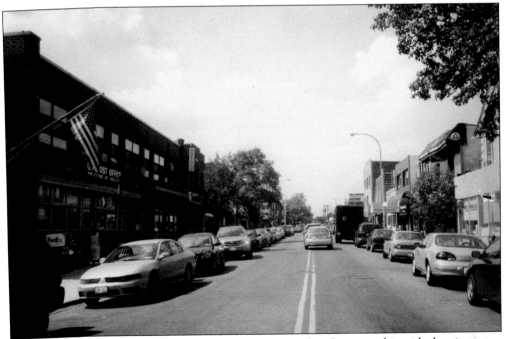

This view shows the main drag of 150th Street as seen today. Compare this with the picture on the bottom of page 26. (Photograph by Jason D. Antos.)

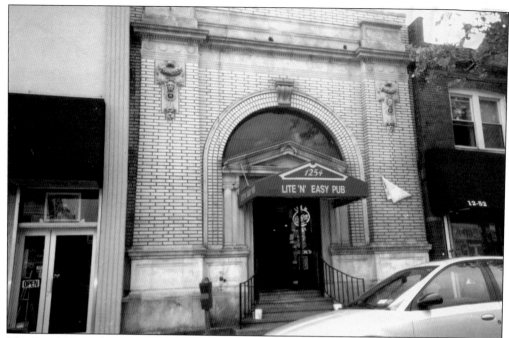

The First National Bank, shown on pages 30 and 31, is now a bar called the Lite N' Easy Pub. (Photograph by Jason D. Antos.)

Long gone and forgotten, this is the former location of McWilliams Brother's Whitestone Coal Pockets Tug and Yacht Supply and Landing Excursion shown at the top of page 42. Though the dock and foundation are still present, it serves as a reminder of Whitestone's disappearing past. (Photograph by Jason D. Antos.)

This alleyway is the actual pathway of where the tracks of the Whitestone LIRR forked off to go toward College Point. (Photograph by Jason D. Antos.)

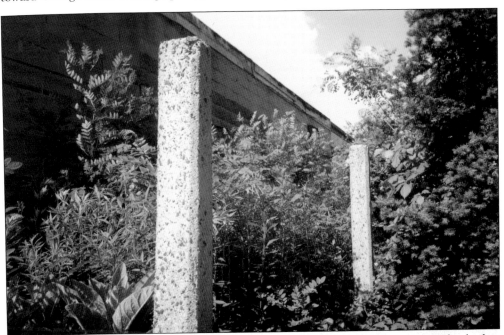

Located at the end of the alleyway is an amazing site, hidden beneath the overgrowth: the last two remaining right-of-way posts that marked the path of the train. These two concrete pillars have been here since 1932, when the LIRR closed down the stations, and it is here that they remain to this very day behind Whitestone Lumber located on Fourteenth Avenue. It is another reminder of what Whitestone has lost over the passing years. (Photograph by Jason D. Antos.)

This is the exact location of the former Whitestone Landing station as seen on page 46. Today this small shopping center is located at Powells Cove Boulevard and 154th Street.

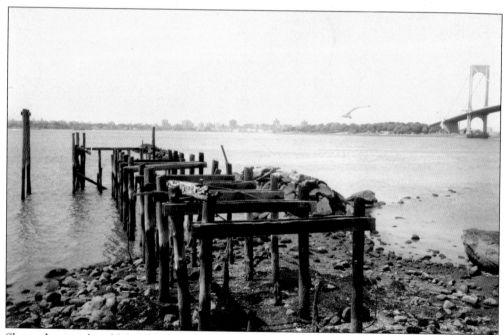

Shown here is the old ferryboat landing located in Malba. The Bronx-Whitestone Bridge is to the right. The slits to the left of the base indicate the spot where the ferries arrived and departed. This abandoned dock is yet another reminder of Whitestone's disappearing history. (Photograph by Jason D. Antos.)

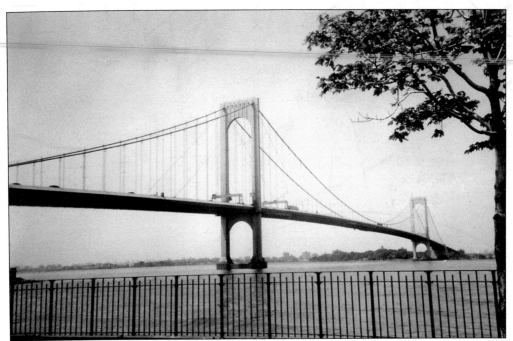

The greatest suspension bridge in the world undergoes renovations beginning in 2003. New paint and a new exterior are placed along the roadway. (Photograph by Jason D. Antos.)

This is the factory started by John D. Locke and was the largest employer in Whitestone. The factory produced tinware products. This picture shows the remains of the abandoned factory located on Clintonville Street. The stone wall at bottom center dates back to 1854. (Photograph by Jason D. Antos.)

Founded by rubber baron Conrad Poppenhusen in April 1868, the Poppenhusen Institute opened its doors on May 7, 1870. The institute served as the nation's first free kindergarten. Located in neighboring College Point, children from Whitestone attended as well. The building that houses the institute can be seen on the right-hand side behind the trees. The Poppenhusen Institute was also beneficial in the making of this book. (Author's collection.)

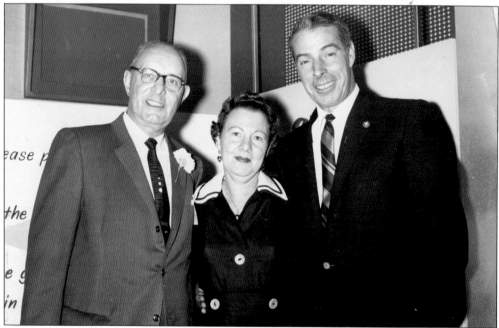

This book is dedicated to the author's late grandmother Evelyn Kaye. She is pictured here with baseball legend Joe Dimaggio (at right) while at a party that took place at the offices of the author's grandfather Milton's paper supply business located on 150th Street in Whitestone. She was in life as she is in this photograph, forever young. (Author's collection.)